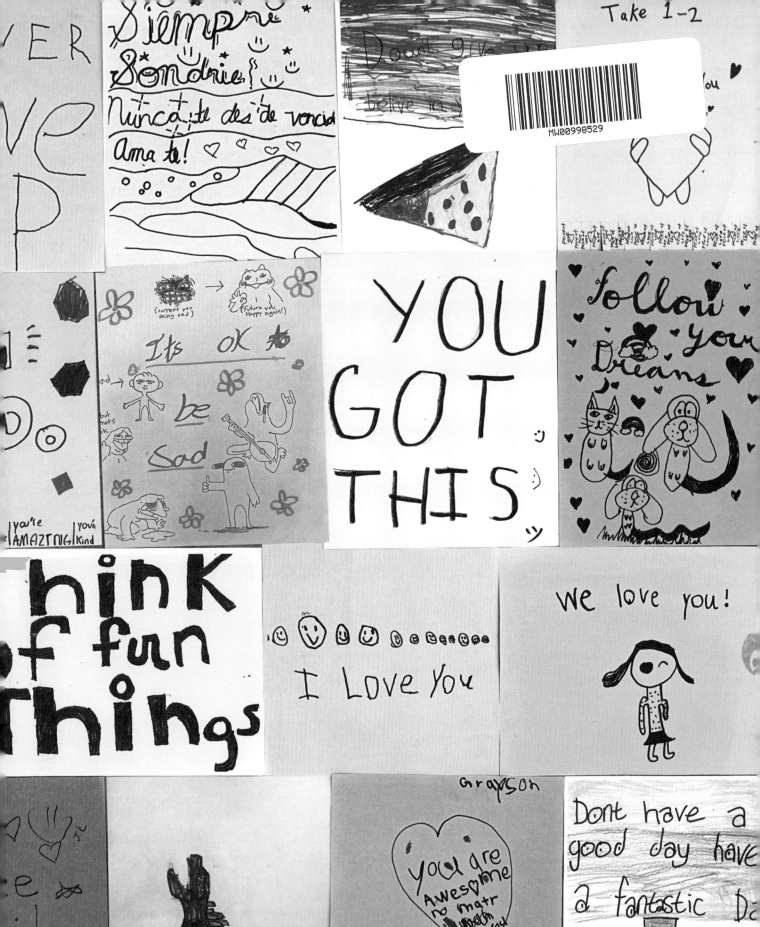

VER
VE
P

Siempre
Sonrie!
Nunca te des de vencid
Amate! ♡

Don't give up
belive in yourself

Take 1-2

you're AMAZING you'r Kind

(current you being sad) → (Future you Happy again!)

Its OK
be
Sad

YOU
GOT
THIS ☺

follow your Dreams

hink
of fun
Things

I Love You

we love you!

Grayson

you are Awesome no matr who you are

Dont have a good day have a fantastic Da

Otheres always a another way.

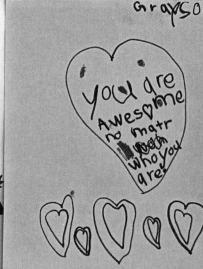

YOU ARE AMAZING LIKE A ROCKET

YOU ARE AMAZING LIKE A ROCKET

PEP TALKS FOR EVERYONE FROM YOUNG PEOPLE AROUND THE WORLD

Jessica Martin and Asherah Weiss

Andrews McMeel
PUBLISHING®

Andrews McMeel Publishing
a division of Andrews McMeel Universal
1130 Walnut Street, Kansas City, Missouri 64106

www.andrewsmcmeel.com

24 25 26 27 28 SDB 10 9 8 7 6 5 4 3 2 1

Trade Edition ISBN: 978-1-5248-8873-2
Library Edition ISBN: 978-1-5248-8874-9

Library of Congress Control Number: 2024931297

Editor: Melissa Rhodes Zahorsky
Art Director: Holly Swayne
Production Editor: Jasmine Lim
Production Manager: Julie Skalla

ATTENTION: SCHOOLS AND BUSINESSES
Andrews McMeel books are available at quantity discounts with bulk purchase for educational, business, or sales promotional use. For information, please e-mail the Andrews McMeel Publishing Special Sales Department: sales@amuniversal.com.

THIS BOOK IS DEDICATED TO ALL YOUNG PEOPLE
AND THE ALLIES WHO SHOW UP FOR THEM, DAY AFTER DAY,
WITH OPEN MINDS AND HEARTS.

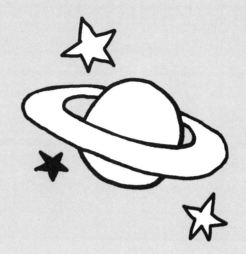

CONTENTS

WHAT IS SOMETHING YOU COULD DO OR SAY TO HELP SOMEONE WHO IS HAVING A HARD DAY?

In early 2022, we asked this question of the students at our local elementary school. Inspired by the powerful creativity, joy, and wisdom youth bring to this challenging world, we decided to create a public art project that would help bring their voices out of the classroom and into the community. We invited the students to make posters with encouraging words and drawings, which we hung up on telephone poles and in windows around our small California town. The students also recorded their messages for a free phone hotline we called "Peptoc." To our astonishment, the hotline went viral two days after its launch that March, receiving sixty thousand calls an hour from around the world—and more than eleven million calls over the course of the following year.

This was at the tail end of our second "COVID Winter" and, in our region, during a severe drought that threatened to fuel wildfires. In the week of the hotline's launch, Russia invaded Ukraine. Amidst all this grief and unrest, handwritten letters poured in from hotline listeners, telling us how profoundly the kids' messages had affected them. Our classroom project had struck a chord on a global scale.

Soon, people began asking for ways to participate in Peptoc—beyond calling the hotline. In response to these requests, we launched a call for youth-made posters: letter-sized creations featuring handwritten messages of encouragement. To help get the word out, we asked our friends and colleagues in other countries to share our call for posters with their larger circles. Seven months and hundreds of emails later, we stepped back and were awestruck by the web of connections that had been woven and stretched around the globe.

This book shares a small sampling of the beautiful responses we received, created by young people from the U.S., France, India, Ghana, Ukraine, Mexico, and many other places in between. Each poster is like a self-portrait of its creator, a reflection of the artist's own experiences, beliefs, and compassion for their community.

The artworks in this book span gender, race, language, stages of childhood and adolescence, culture, class, and five continents. We received submissions from twenty-five countries, from people between the ages of six and twenty-one. In selecting works to feature, we ensured that every country and age group was represented, taking special care to include unique perspectives and highlight common themes. Throughout this process, we were very aware of our own limitations: our cultural and social contexts and biases, as well as others' barriers to access. With that in mind, our goal is to celebrate the communities we have had the privilege to work with so far and to invite others to expand the project beyond our reach.

In addition to a warm smile, we hope this book will bring you a deeper appreciation for the power of young people. We adults frequently tell children that one day they will grow up and change the world. However, the posters collected here are reminders that young people have the resilience, brilliance, and creativity to transform our world *now*. If we listen, they can teach us—in the words of Kristina, a young Ukrainian woman whose work is featured here—"how to be humans to each other."

In hope and gratitude,
Asherah + Jessica

THE POSTERS

Feel the good vibes

Text on Tabs: Chill / Turn a bad thing into a good thing / It's ok to have a bad day / It's ok to be different / Shine your light / The day will go by quick / Everything is OK / Have a good time / Enjoy yourself / Give yourself a hug

Lily, age 9, Windsor, California, USA

Feel the good
Vibes

chill

Take a
bad thing
into a good
thing

It's ok to
have a bad day
it's ok to
be different

shine for
light

that day
will go
by quick

Everything
is ok

have a
good time

enjoy
yourself

give your
self a
hug

You are a million great things!

Oliver, age 8, Philadelphia, Pennsylvania, USA

"I want everyone to see the great in themselves."

YOU ARE a million great things!

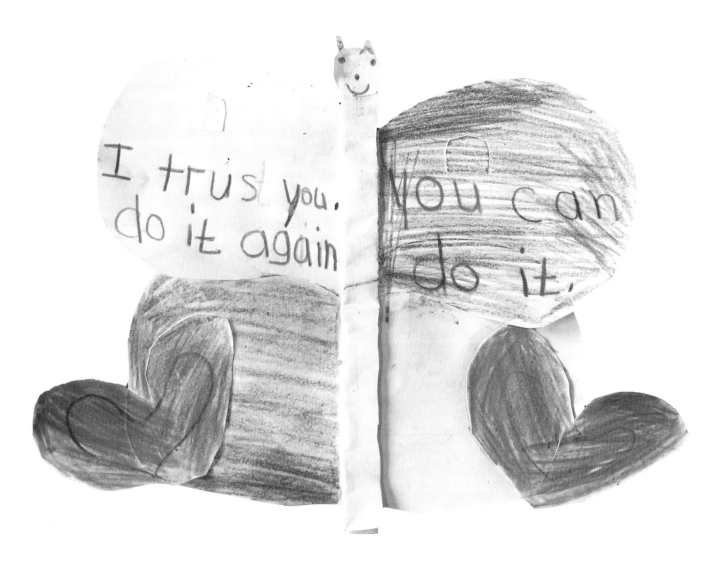

I trust you. Do it again. You can do it.

Mickayla, age 9, Cape Town, South Africa

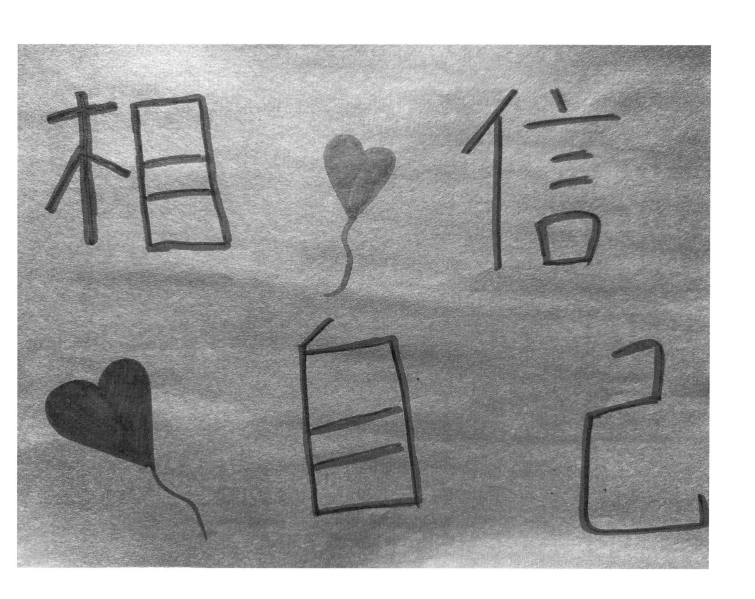

(Translated from Mandarin)

Believe in yourself

Navya, age 16, Taichung City

The world is full of love so cheer up

Rejwana, age 16, Bronx, New York, USA

The world
is
Full of love
so
cheer up

♥ ♥ ♥

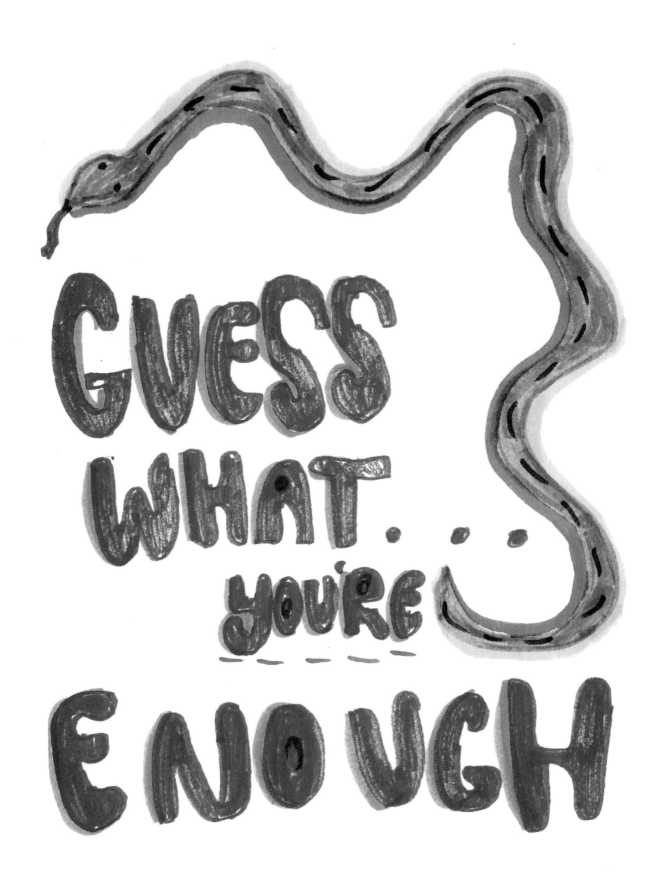

Guess what…you're enough

Audrey, age 18, Dothan, Alabama, USA

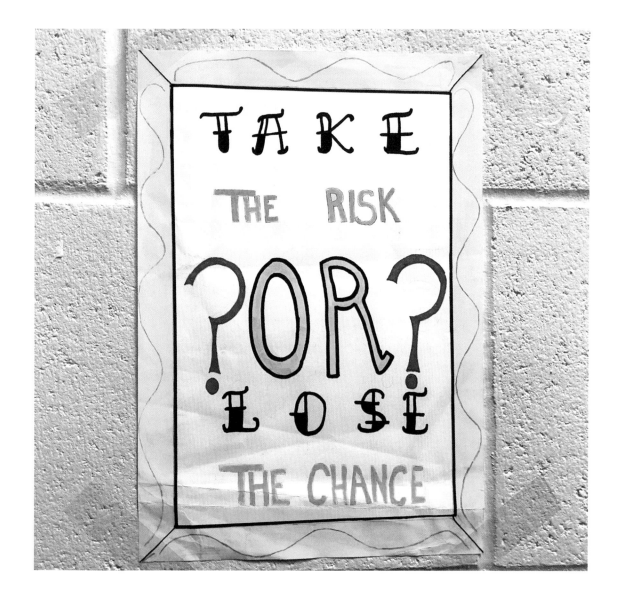

Take the risk or lose the chance

Lilly, age 13, County Mayo, Ireland

Be happy

Sharmadha, age 7, Edayanchavadi, India

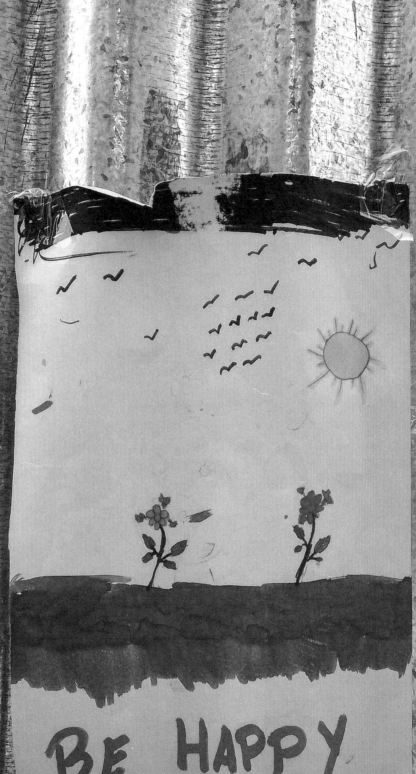

(Translated from Hebrew)

Take some kind words for yourself.

Text on Tabs:

You are beautiful / You are amazing / You're smart / You're nice / You only do fun things

Tamar, age 12, Rehovot, Israel

"People aren't told how much they are smart and amazing."

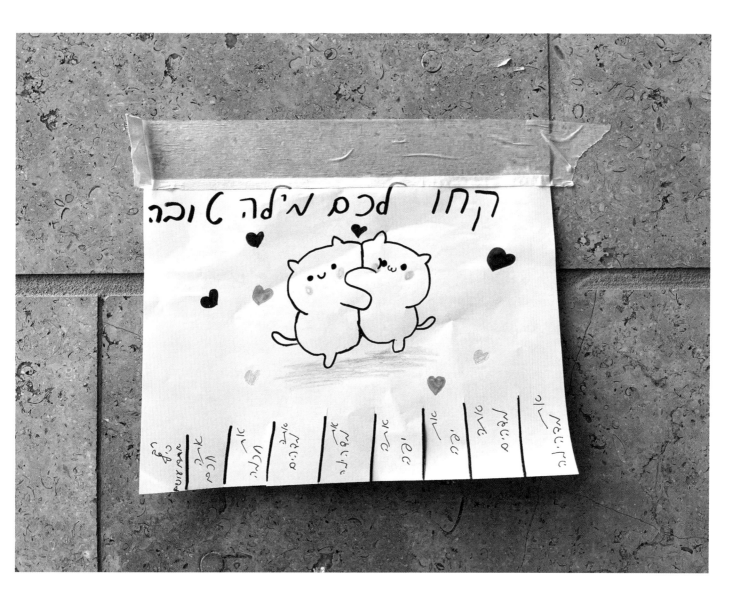

(Translated from French)
Life is beautiful. Look around you, you'll see.
Clara, age 6, Montpellier, France

la vie est jolie regarde
autour de toi tu verras

I's okay to take a break, don't overwork yourself

Alyssa, age 15, Santa Rosa, California, USA

"Sometimes people forget about themselves and need to be reminded to relax."

I's OKay To Take A Break, Don't Overwork Yourself?

You are worth it

Jude, age 12, Graham, North Carolina, USA

Love yourself, because at the end of the day, you're the best friend you'll ever have!

Mylah, age 17, Dothan, Alabama USA

"I wrote 'love yourself' because I struggle with that the most."

Kick up! Don't give up!

Claudia, age 6, Yarraville, Australia

"My message helps others because it says, 'kick up your heels, don't give up, keep on trying!'"

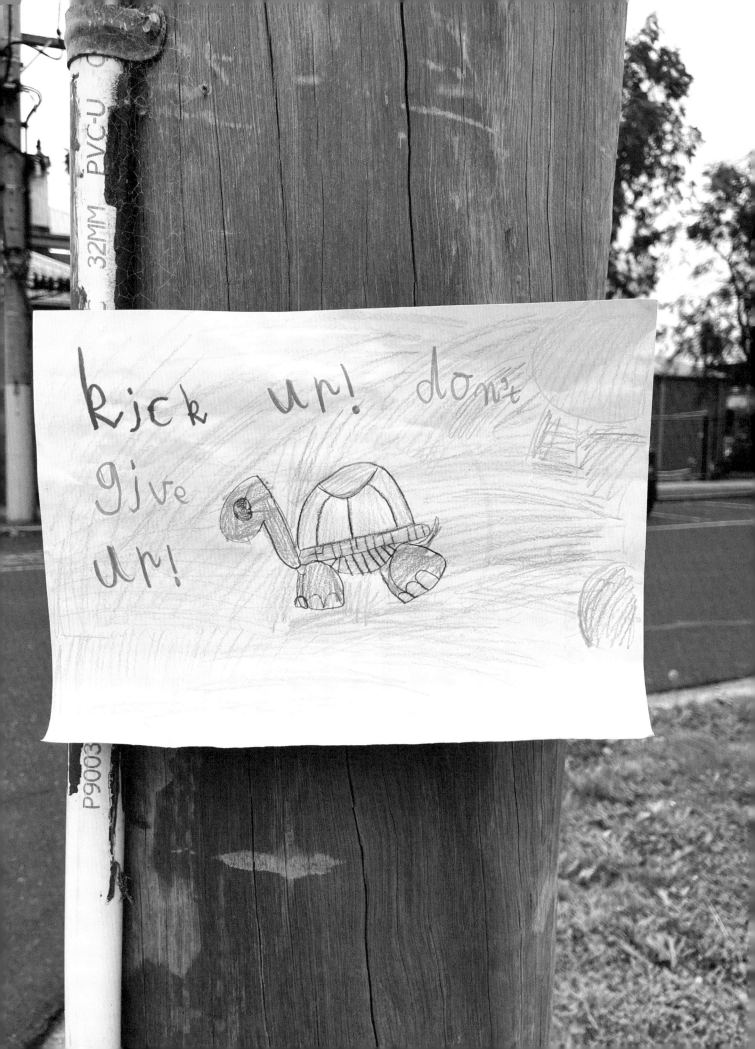

Don't forget—you are the main character of your story!

Kristina, age 17, Sasiv, Ukraine

Én vagyok a történetem főszereplője! Én likezik ♡

Не забувай

Tudd hogy a mindenhole att van!

Пи

Головний герой своєї історії

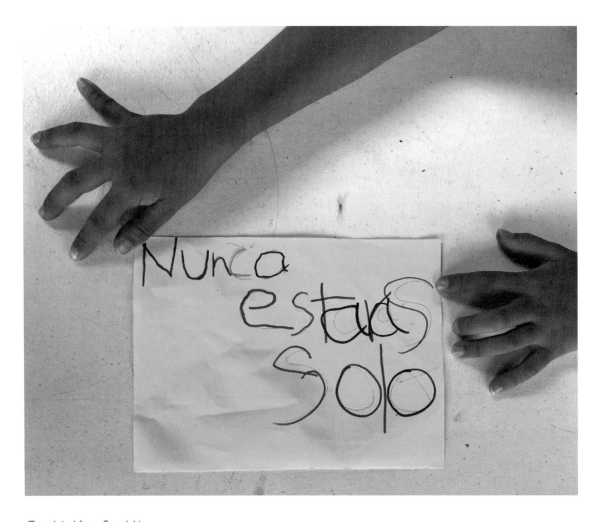

(Translated from Spanish)
You are never alone

Genesis, age 5, San José, Costa Rica

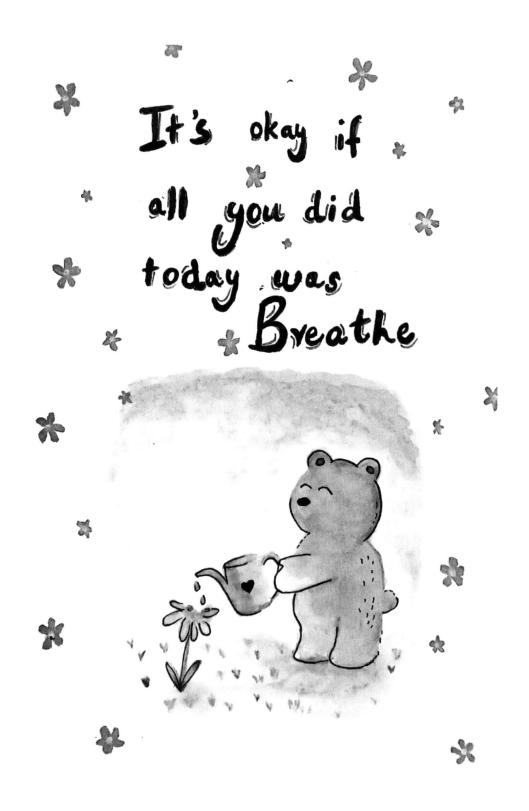

It's okay if all you did today was breathe

Shiza, age 20, Karachi, Pakistan

"It's okay to take a break and relax and breathe, because that's what your body needs. No one should feel ashamed to do that."

Your only limit is your mind!

Erin, age 12, Cape Town, South Africa

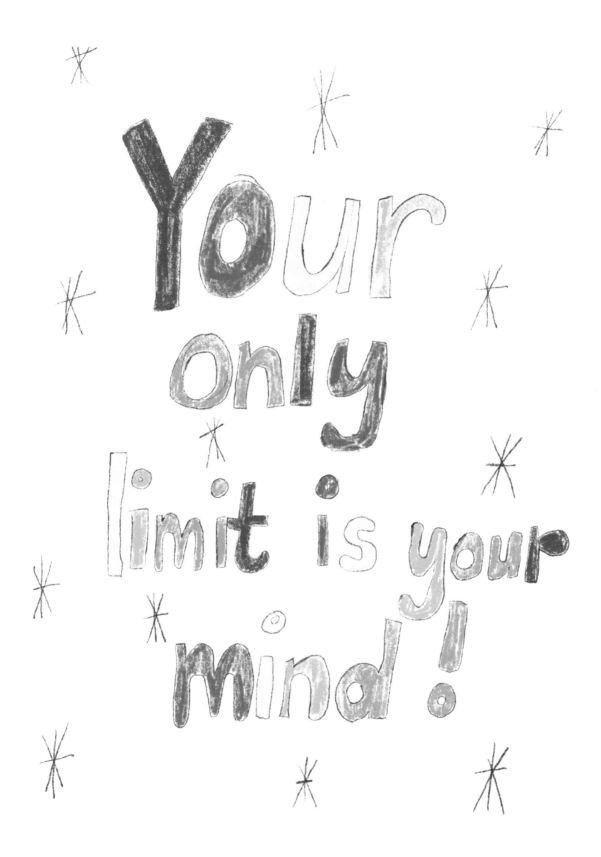

(Translated from Korean)

I love you. You can do it. You look beautiful. Well done. You are really cool. Believe in yourself. Everyone believes in you and supports you. I'm proud of you. You're precious. I trust you. I like you.

Hyejoo, age 16, South Korea

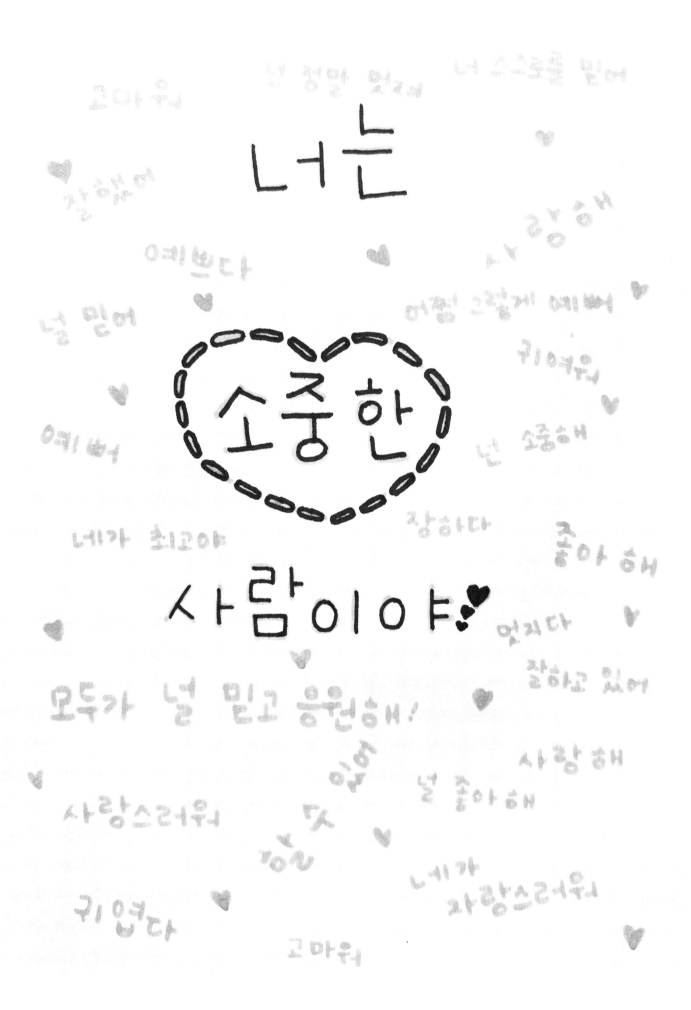

(Translated from Spanish)

Sadness is <u>not</u> permanent.
A joke for you!

Sample Joke: Why do flamingos raise one leg? Because if they raised both they'd fall down.

Santiago, age 6, Buenos Aires, Argentina

"I want to remind them that sadness is also impermanent and will eventually pass. The jokes should make them laugh so it happens right away!"

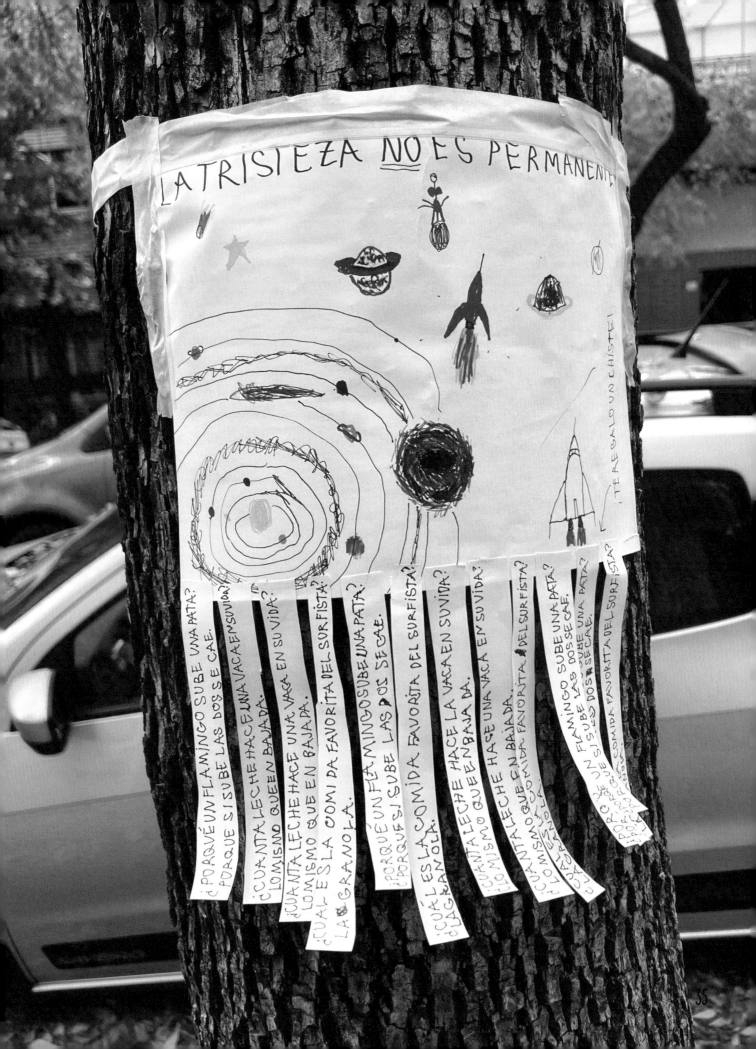

Stressed spelled backwards is desserts.

Kulkunya ("Dream"), age 17, Nakhon Sawan, Thailand

"Eating dessert makes me feel more relaxed."

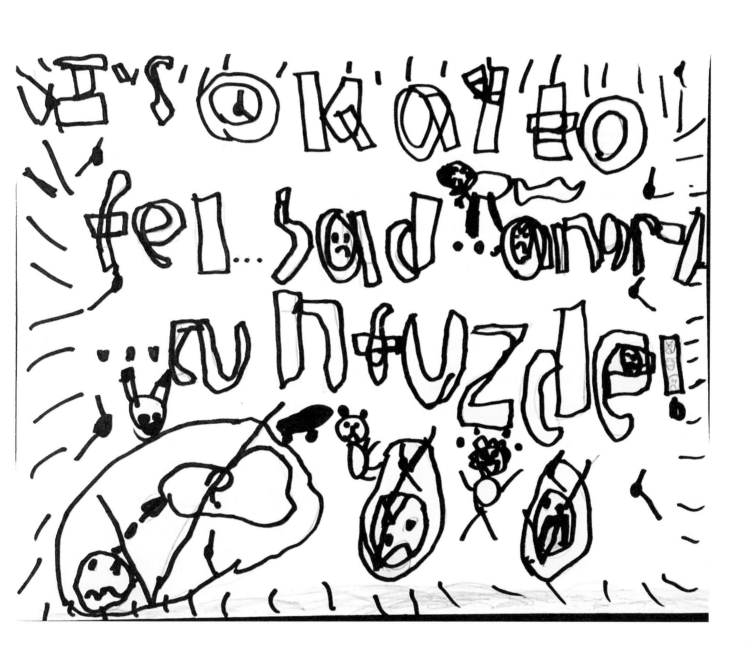

It's okay to feel…sad…angry…confused!

Jude, age 8, Philadelphia, Pennsylvania, USA

"When people feel sad and feel like they can't finish their work, they can think about what I said and feel better."

37

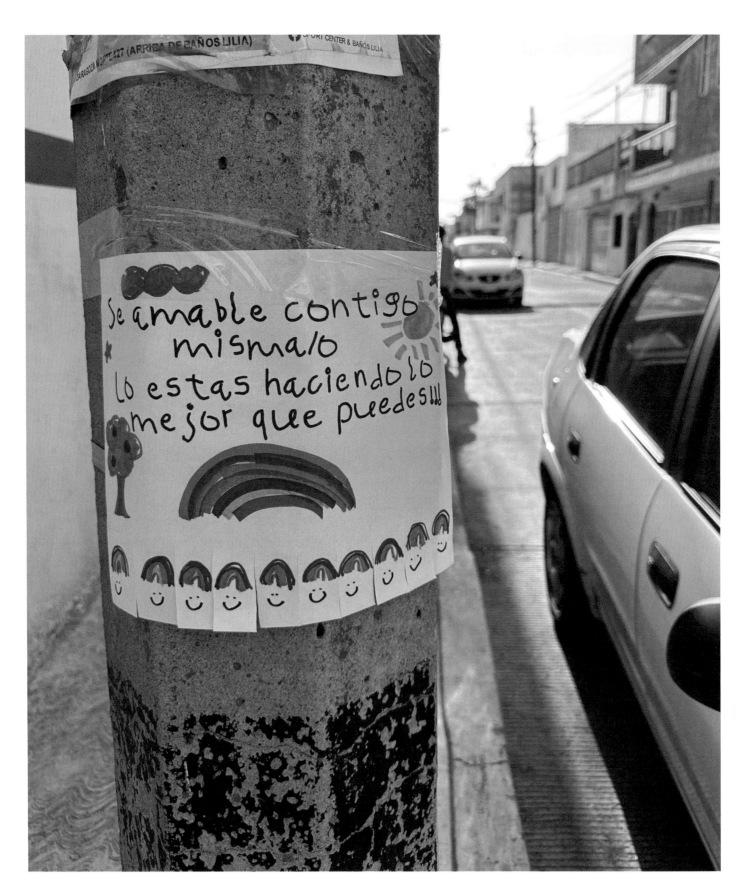

(Translated from Spanish)

Be kind to yourself, you are doing the best you can!!!

Paula, age 9, San Martín Texmelucan de Labastida, Mexico

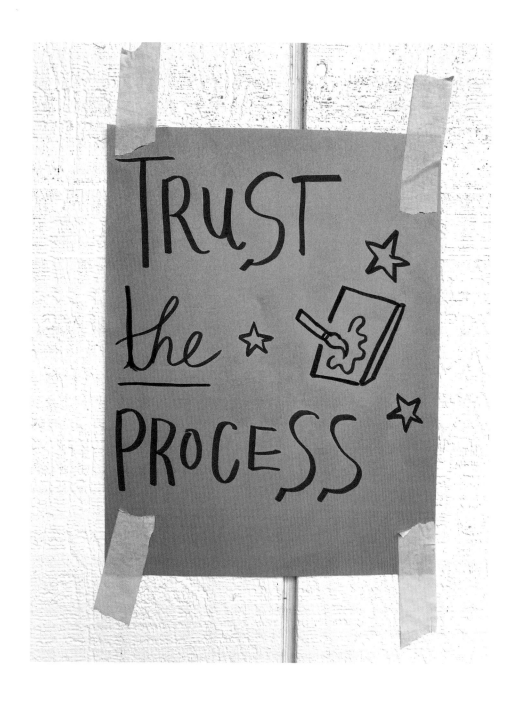

Trust the process

Mira, age 17, Santa Rosa, California, USA

"While things won't always seem like they're going to be okay, it's important to trust what you're doing and wait for the final result. You can't judge a work in progress with finality. You have to trust the process."

Read these cute facts if you are feeling down (Warning: they <u>will</u> make you smile)

Text on Tabs: Sea otters hold hands while they sleep so they don't drift apart / Penguins 'propose' to another penguin with a pebble / Mice and rats are ticklish—and they laugh when you do it / Squirrels adopt other squirrel babies when they've been abandoned / Bees dance to communicate / Cows have BFFs / Japanese macaques make snowballs for fun

Ainhoa, age 17, Asunción, Paraguay

READ THESE CUTE FACTS IF YOU ARE FEELING DOWN

(WARNING: THEY _WILL_ MAKE YOU SMILE)

SEA OTTERS HOLD HANDS WHILE THEY SLEEP SO THEY DON'T DRIFT APART ♡

PENGUINS 'PROPOSE' TO ANOTHER PENGUIN WITH A PEBBLE

MICE AND RATS ARE TICKLISH—AND THEY LAUGH WHEN YOU DO IT :)

SQUIRRELS ADOPT OTHER SQUIRREL BABIES WHEN THEY'VE BEEN ABANDONED

BEES DANCE TO COMMUNICATE

COWS HAVE BFFs

JAPANESE MACAQUES MAKE SNOWBALLS FOR FUN

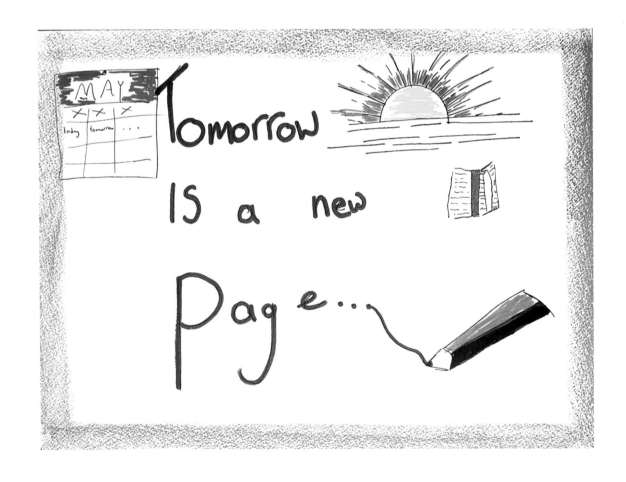

Tomorrow is a new page...

Eliza, age 12, Adelaide, Australia

"I think my message will help others because it encourages hope about the future and even letting go of worries about the past."

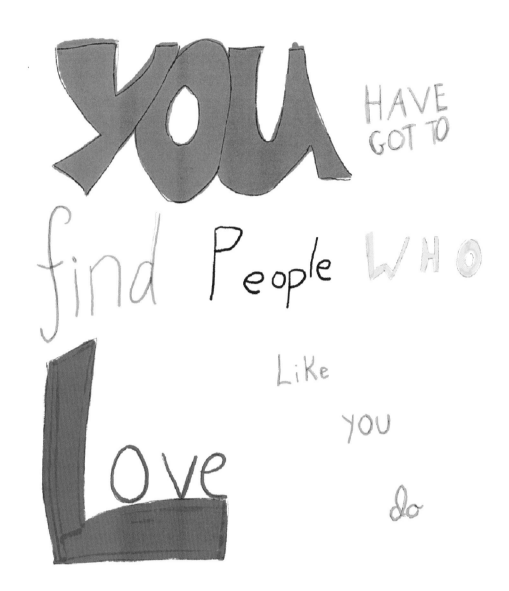

You have got to find people who love like you do

Orla, age 13, County Mayo, Ireland

(Translated from Finnish)
You're gorgeous
Hilla, age 17, Oulu, Finland

Help people when you don't even know them

Maya, age 6, Philadelphia, Pennsylvania, USA

Help people
when you
dont even
know them

(Translated from Urdu)

We are human, not flowers that have to be in bloom all the time

Aamna, age 20, Karachi, Pakistan

"These are the only words I've wanted to hear all my life . . . I want to let everyone know that it's okay to take a break once in a while and be yourself. We don't have to be perfect all the time."

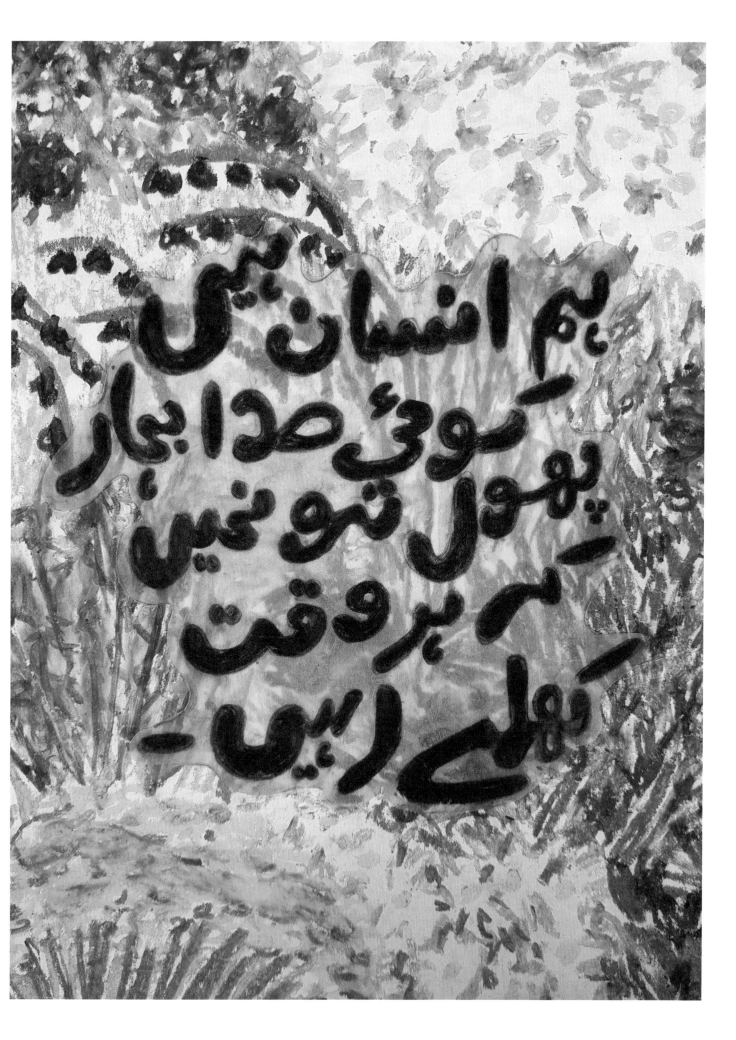

ہم انسان نہیں
موتی صدا بہار
پھول ہو نہیں
مگر وقت
کھلے رہیں ۔

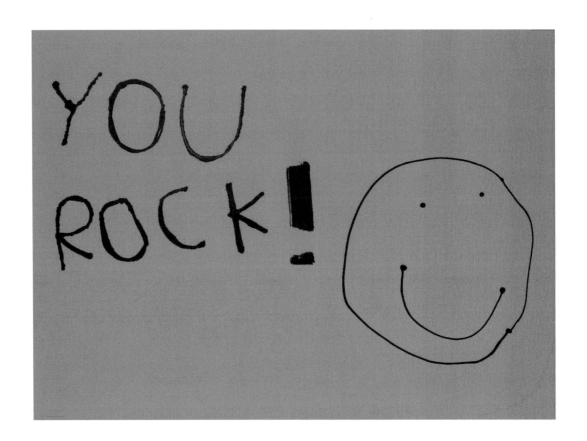

You rock!

Elena, age 6, Vigo, Spain

"My poster has positive vibes."

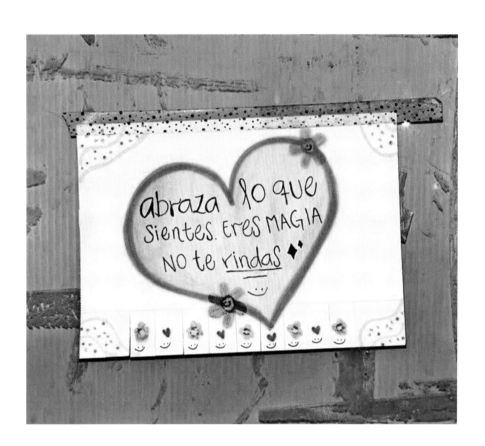

(Translated from Spanish)

Embrace your feelings. You are magic, don't give up :)

Jessica, age 20, Puebla, Mexico

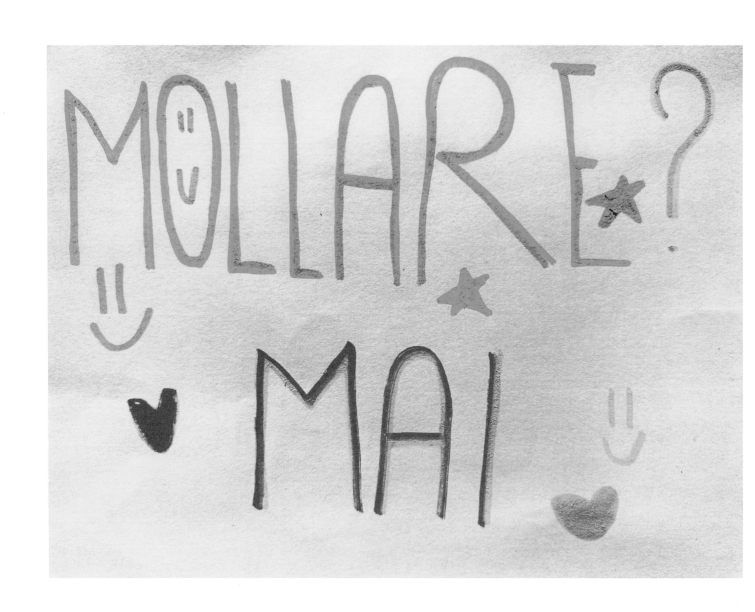

(Translated from Italian)
Give up? Never.

Chiara, age 18, Cagliari, Italy

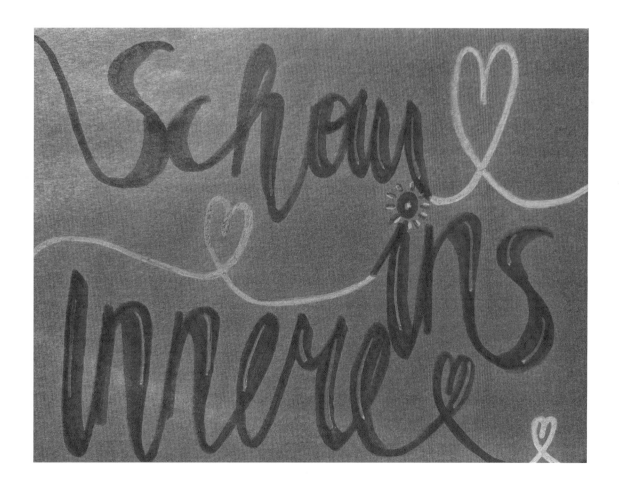

(Translated from German)

Look into the inside

Matilda, age 18, Irdning, Austria

**"Some people judge others based on how they look, but we should all look into
the inside before we start judging."**

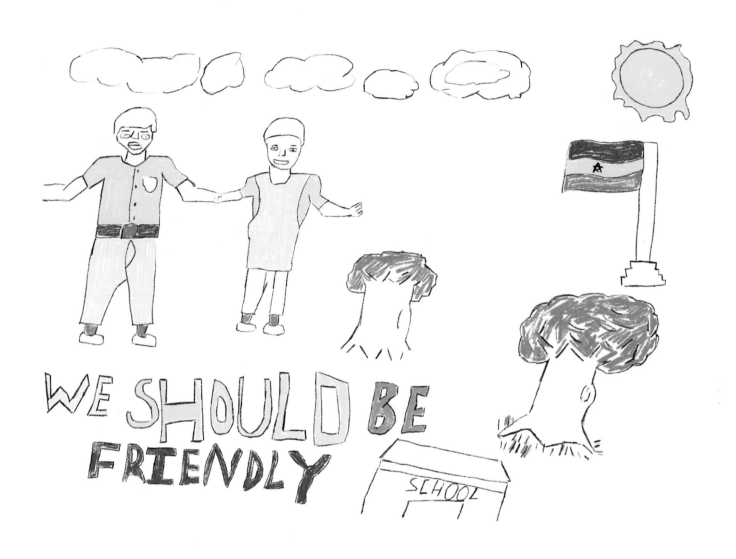

We should be friendly

Emmanuel, age 10, Accra, Ghana

"If everyone is nice to each other, we will be happy."

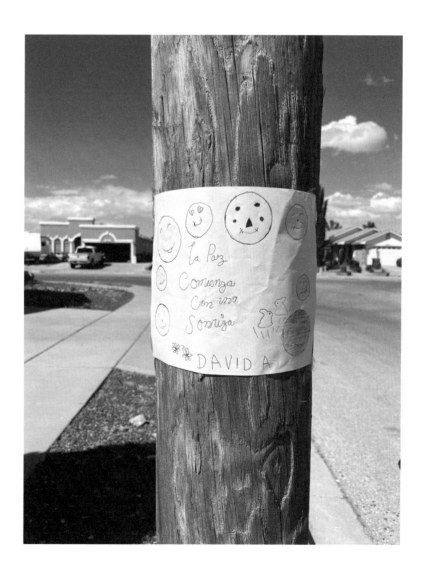

(Translated from Spanish)

Peace starts with a smile

David, age 17, Horizon City, Texas, USA

You are so important

Ian, age 7, Philadelphia, Pennsylvania, USA

你是如此重要

We are proud of you…

Fatoumata, age 13, Brikama, Gambia

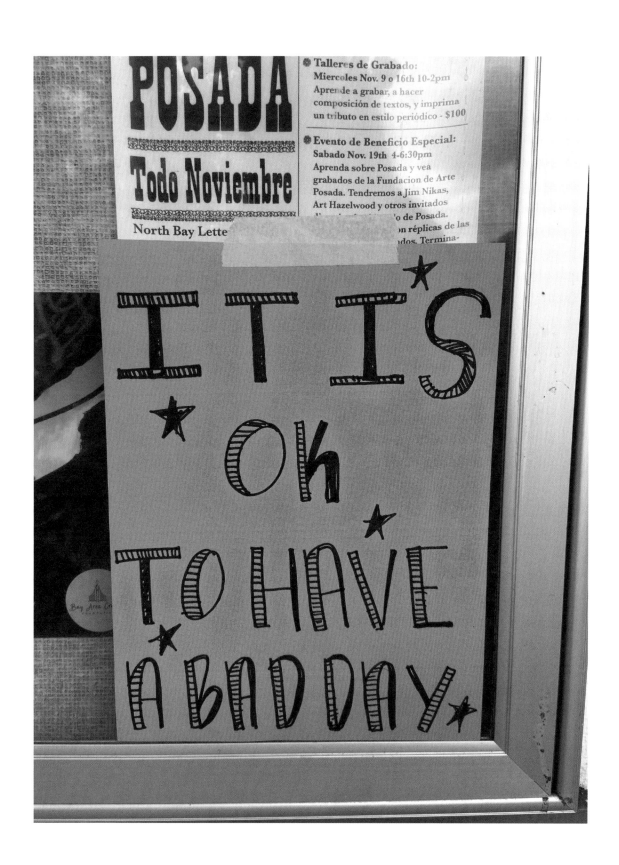

It is OK to have a bad day

Ava, age 18, Santa Rosa, California, USA

Don't worry, today is just a bad day, it's not the end of the world! Plus you never know what tomorrow has in store for you! Just remember—live life the way you want it to be!

April, age 12, Healdsburg, California, USA

"Some people feel like there is nothing good in life or they won't find anything good, so I wrote this message to try and bring hope to all those people. I wanted to tell them that there is something good in life and if they haven't found it, then I'm sure it's coming their way."

Don't worry

today is just a bad day,
it's not the end of the
world!
Plus you never
know what tomorrow

has in store
for you!

Just remember

live life the way

you want it

to be!

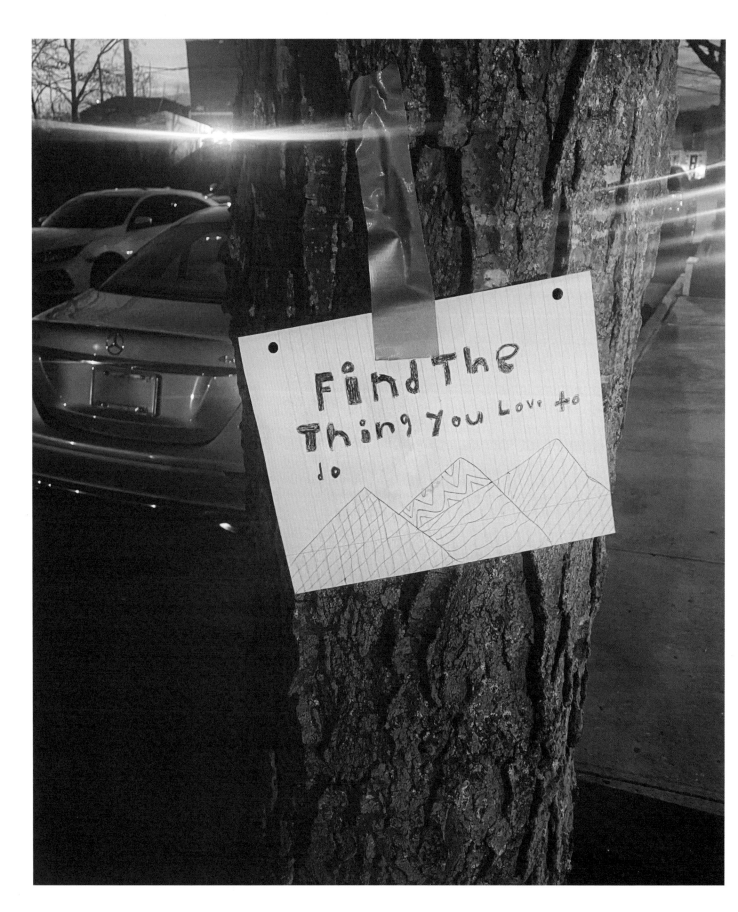

Find the thing you love to do

Gabriel, age 16, Bronx, New York, USA

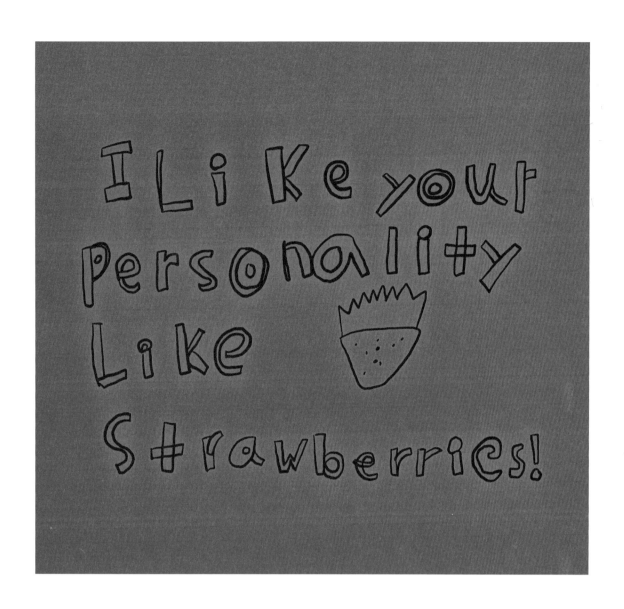

I like your personality like strawberries!

Abigail, age 7, Philadelphia, Pennsylvania, USA

I think you're great! So do they.

Ciara, age 15, Austin, Texas, USA

"I hope this message will cheer people up because they see the cute animals or the mildly cheesy caption."

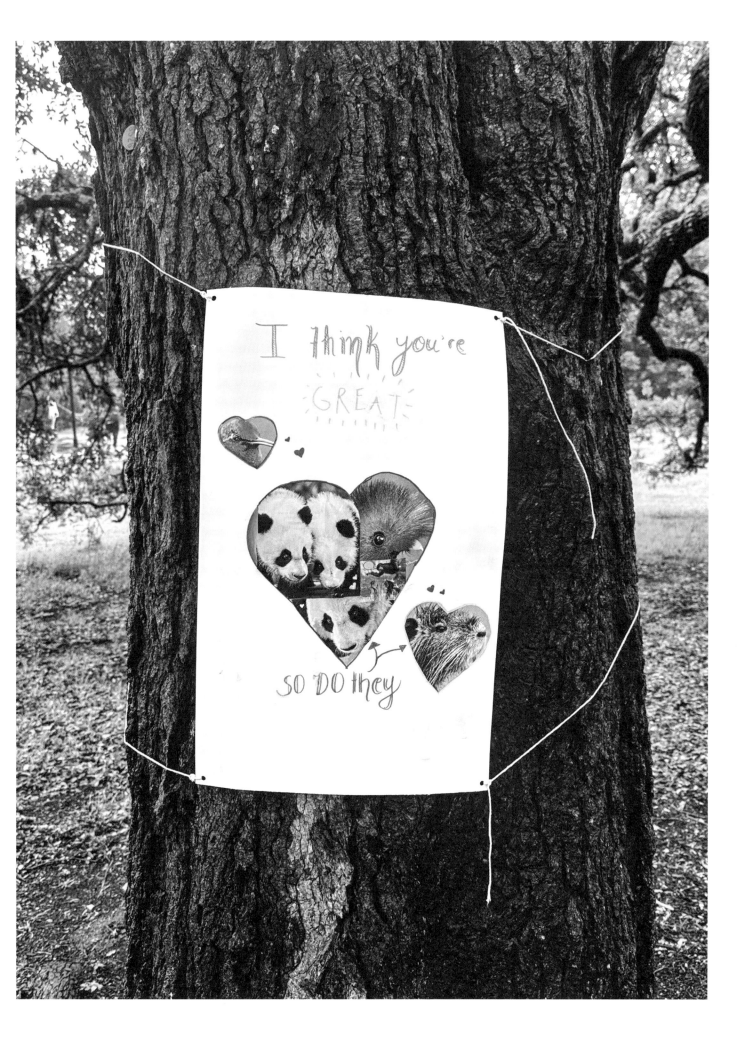

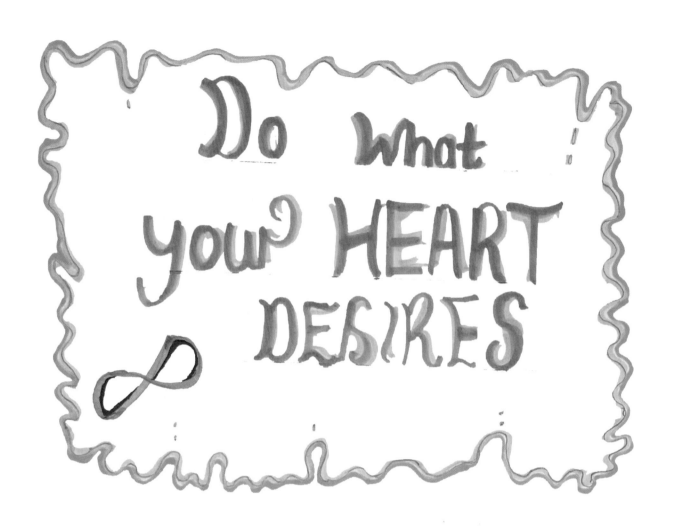

Do what your heart desires

Ricaylia, age 12, Cape Town, South Africa

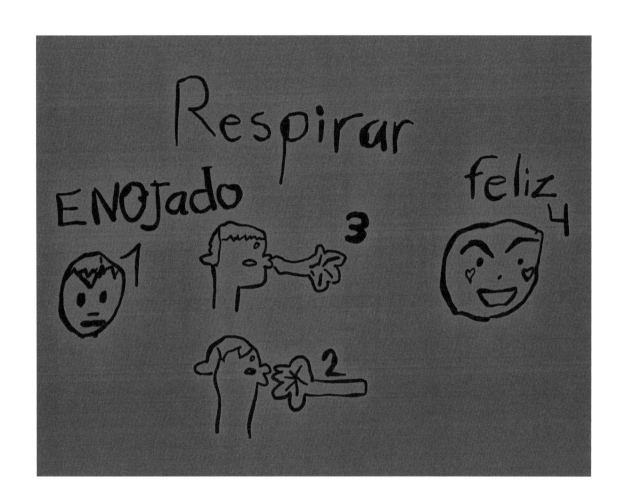

(Translated from Spanish)
Angry / Breathe / Happy

Alexandra, age 10, San José, Costa Rica

WEST SIDE ELEMENTARY AND THE ORIGIN OF PEPTOC

The children of West Side Elementary in Healdsburg, California, who range in age from five to twelve, are the inspiration behind Peptoc. They made the first posters for the project, and their voices were recorded for the hotline. (Readers who have called the hotline may recognize some of the messages in the following pages.) Jessica's son, then a first grader at the school, even coined the spelling of Peptoc, sounding it out for a sign he made.

When the project launched in March 2022, these children were just beginning to recover from the experiences of the COVID-19 pandemic. On top of this, multiple wildfires had torn through our region in recent years, and several students at West Side had lost their homes. These kids, like many young people, were navigating major difficulties in their early years, and we could see that they were carrying a heavy burden of grief—their own and that of the world.

"We all love each other. We are family. We are all human. People need to know that we care about one another. We all make mistakes, we all do bad and good things, but we can change ourselves to be better."

—Yuliana, 4th grade

When we asked what advice they had for how to get through a hard time, they didn't hesitate. It was clear they'd had to think about this daily, and we felt honored they were willing to let us share their wisdom with our larger community.

As the project spread beyond our little town and into the world, the school was suddenly flooded with newspaper, television, and radio reporters. It was extraordinary to watch our students be revered as the wise, humorous teachers they are.

"I was amazed by how our small school made such a big impact. It means that people actually believe in kids."

—Deegan, 5th grade

With over twelve million calls to their hotline and hundreds more posters made and shared all over the world, the kids of West Side have truly started a movement: one centered on creativity, joy, and the power of young people's voices.

The following are just a few of the 180 posters created at West Side. Enjoy them on your own or share them with others who could use a boost!

"It makes me feel happy that people are actually listening. Before I didn't think people would care, but now I know they do."

—Sydney, 5th grade

HEALDSBURG

UNA LÍNEA TELEFÓNICA ATENDIDA POR NIÑOS CONSEJEROS

Telemundo48 5:08 63° 48

"I realized that this is actually really helping people and might even save lives."

—Rylee, 5th grade

Yr the best.

Si estás triste ve a comprar unas donas

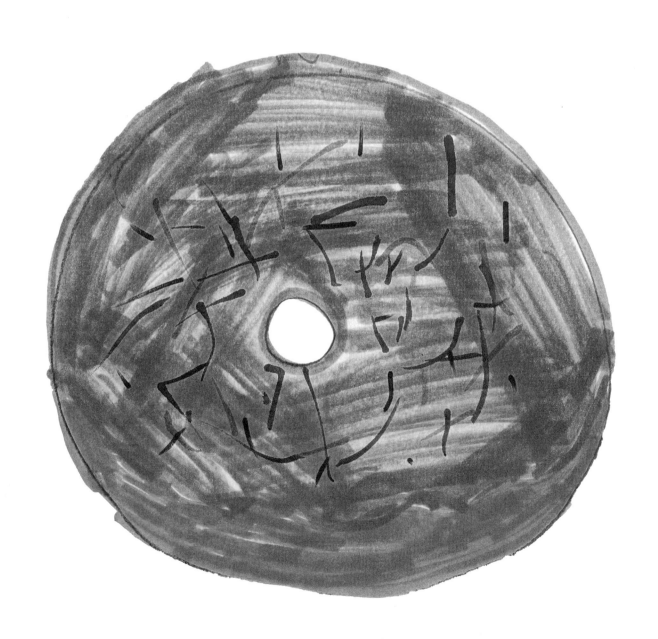

If you are sad, go buy some donuts.

IF YOU'RE ANGRY, GO PUNCH A PILLOW, CRY ON IT, OR JUST GO SCREAM OUTSIDE

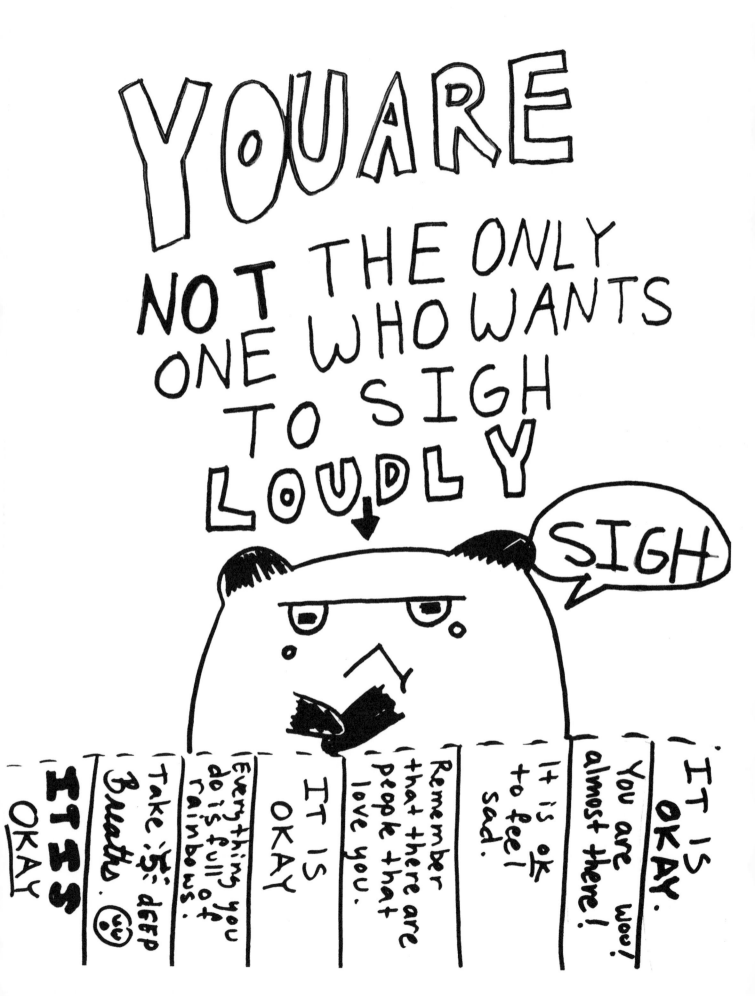

IF YOU'RE FEELING UP HIGH AND UNBALANCED THINK OF

GROUNDHOGS

If you're feeling

NERVOUS

GO get your

WALLET-

BUY

& ICECREAM +

SHOES

The World is
a Better Place
With You in it!

THE INTERVIEWS

We've been fortunate to connect with some of the people and organizations who responded to our call for posters. In speaking with these youth and their mentors from around the world, we were fascinated to discover common concerns, observations, and ideas.

First: The creative mindset—that space of imagining new futures, taking risks, and inventing joyful solutions—is key to connecting with ourselves and with others. Young people are especially gifted at entering a creative mindset, but it's up to the adults—the educators, artists, parents, and other allies who surround them—to maintain safe spaces of exploration.

Second: "Creativity" is not confined to traditional modes of artistic expression, like painting and drawing. Creativity can look like a conversation, trying something new, or even displaying a poster with a kind message in your neighborhood.

And third: We are more resilient when we turn our focus to the positive and innovative work being done in this complex world. Wherever there is pain and despair, there is almost always someone working for real, replicable, positive change. Exposure to the work of positive changemakers helps us process our heartbreak; it makes us more likely to push past feelings of hopelessness and find ways to contribute.

Although these interviews offer only a small window into the lives of these young people and their adult supporters, we hope their insights remind readers of the good work that happens every day at the community level all around the world.

GHANA

King and Jordan are the founders of Akwaaba Volunteers, which provides after-school educational support to young people in King's hometown in Ghana. King—a former professional soccer player in the UK—created the program to give back to his community.

PEPTOC: Why do you think your program is so successful?

JORDAN: We never start a project without the support of our community because it just wouldn't be sustainable. All of our projects are now run by local people because that's what's going to make the real change. Whether that's the kids, the parents, or community leaders, we make sure our projects are aligned with their ideas so they're involved in every step and see them flourish.

PEPTOC: In what ways does local culture inform your programs?

JORDAN: Sports are a big part of local culture. Every corner you turn down, you'll see kids playing football. One of the things we've done well is to use sports as a tool to engage with kids who may otherwise be uninterested in much else—like going to school. They're still happy because they get to play sports, but they're learning other skills along the way, such as teamwork or leadership, which can create job and educational opportunities.

PEPTOC: Why did you decide to participate in the Peptoc project?

JORDAN: It was an opportunity to participate in a different means of self-expression. There are kids who may learn from watching things or drawing things as opposed to reading or writing, and some might struggle because they just don't have those opportunities. Also, for this project, they weren't limited as to what they could write or draw—they had freedom. It was inspiring for them to see other kids in California doing the same thing and to feel connected to something that was bigger. They were proud of the work they made.

PEPTOC: How do you think creativity helps the young people you work with?

JORDAN: Many of the kids have a lot of things going on at home, whether it's financial or chores to do. Some of them have to work after school or after training to get enough money to eat each day. They have more on their minds than most kids would probably ever want to think about. Giving them that opportunity to be creative gives them a chance to feel free and express themselves in whatever way they wish. Having creativity as part of day-to-day life opens more doors for more kids. It also helps kids who are struggling with conventional education. They might just need to learn in a different way, which is fine. We need to understand that and embrace it.

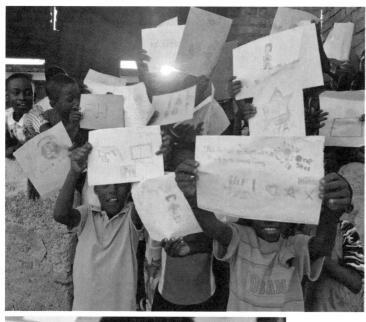

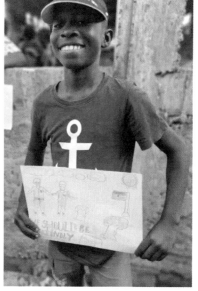

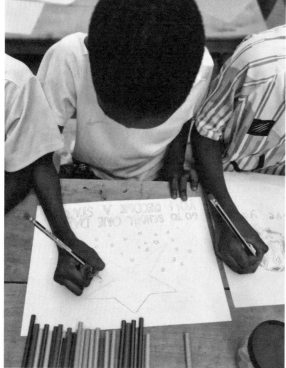

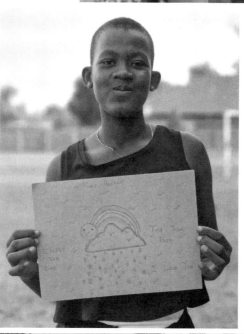

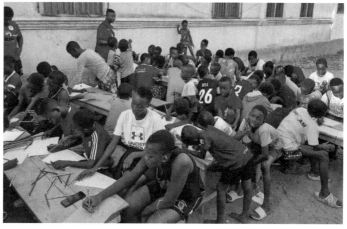

FRANCE

The Antonia International School is based in Montpellier, France, and offers instruction to children from toddlerhood through high school. A registered "eco-school," it participates in actions for peace through its partnership with UNESCO.

(Interview translated from French)

PEPTOC: How did you present the Peptoc project to your students?

AIS: This year, the students have worked a lot on the themes of water, the protection of our planet, ecological concerns, and caring for living things. The Peptoc project naturally fits into our approach and vision of the world.

We told the students that their drawings and messages could be shared around the world and bring comfort to those who are sad or lonely—a message or a drawing to brighten someone's day, encourage someone to take care of others, or to see and think about the beautiful world around us . . .

PEPTOC: How was the experience of hanging the posters in public?

AIS: The children were very happy to walk around the school's neighborhood, taking care to find the best locations for their drawings so that passersby could easily see them. They wanted to display some drawings at the pharmacy because, they said, "The people who come here are not feeling so well." A student took us to the retirement home where his grandmother lives in order to, they said, "Bring joy to the old people."

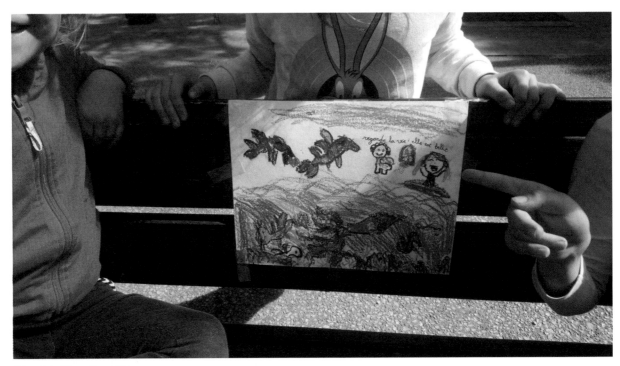

(Translated from French)

Look at life, it is beautiful.

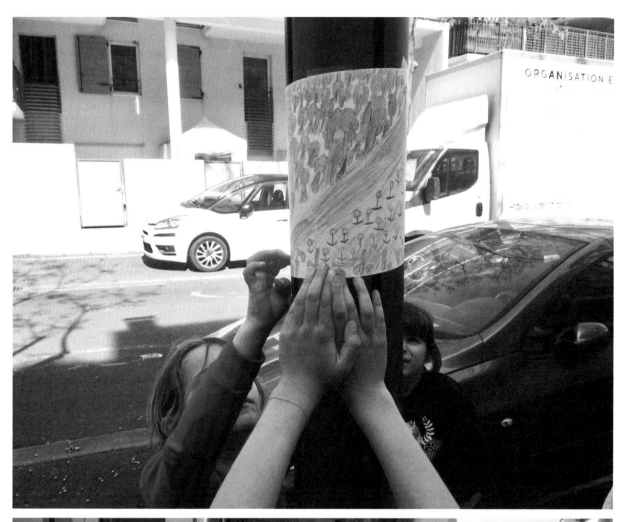

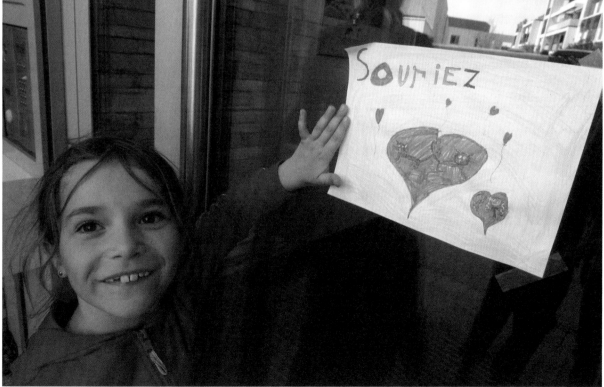

Smile

PHILADELPHIA, USA

Ali is a professional artist and educator in Philadelphia. When she first called the Peptoc Hotline, she was in tears from laughing so hard and thought, "This is exactly what we need." She was thrilled to discover our poster project and brought it to McCall Elementary in Philadelphia, where she was working as a student teacher. Kindergarten, first-grade, and second-grade students at the school made posters, and afterward, Ali and her co-teachers invited them to take a microphone and give in-person pep talks to one another. The posters and a video of the live pep talks were shown at a local university. The show inspired the college students to hang up their own small Peptoc posters as positive feedback for the young McCall students.

PEPTOC: How did you get your students interested in the project?

ALI: I pulled a bunch of visuals from the Peptoc website and said: "Look, there are these other young people who did this project in California, and look what they made!" That was the spark that got them really excited. I think when young people see art made by other young people, [the impact] is really direct.

PEPTOC: Why did the project speak to you initially?

ALI: At its core, I think [Peptoc] is about relating to another person, which was really direct and clear. I feel like people want to be kind to each other. If you give people the space or opportunity to do that, to come up with a message about joy, it just evolves into a greater thing—because people want to be a part of it.

I think the main thing is that this project is accessible. "Inclusivity" gets tossed around a lot, but here, inclusivity meant a lot of people showing up to a place and doing something together, and it was like a party.

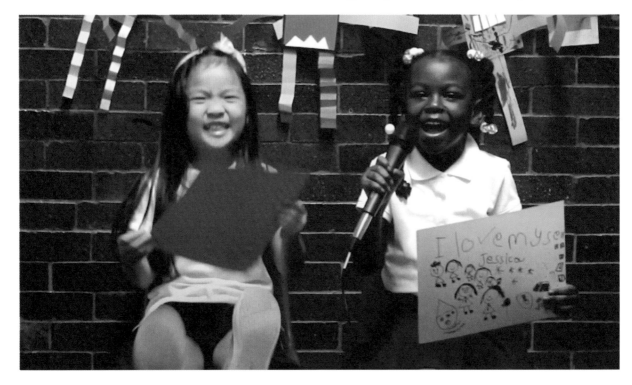

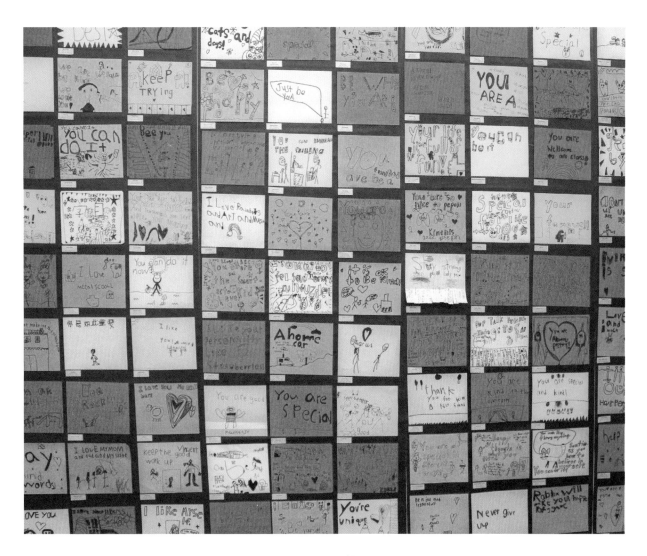

PEPTOC: Were there any surprising or revelatory moments?

ALI: It was really lovely to see students helping each other figure out what their message was going to be, helping each other spell things, or coming up with a drawing collaboratively. At the same time, out in the hallway, there were two chairs and a microphone, so two by two, the kids would come out and give their pep talk. The reason we brought two kids outside at once was to encourage anyone who'd had trouble finding their voice to feel a little safer speaking in front of others. That was really fun. Even the microphone itself was a fun addition that made the kids feel that what they had to say was important. I think young people aren't told that explicitly enough: "What you have to say is important, and here's how important it is."

PEPTOC: What can we learn about creativity from these young students?

ALI: Young people are amazing. Their art is amazing. They haven't been told yet that they are "good" or "bad" at art. They are just making art—and a lot of it. You know this if you're around them; there are a lot of drawings and a lot of ideas, and they don't have the same insecurities that come in as you get older.

We get all these messages telling us we can or can't do things. But just continuing to make is important. If you have an idea, it can be a drawing, and then it can be a song, and then it can be something you share with your friends—like a card.

Creativity should be cherished and encouraged all the time. It's so important because we need these young people to become the adults who keep that spark alive.

CALIFORNIA, USA

Harriet and Brian, both career educators, are a married couple who volunteer for the Rotary Youth Exchange program in Northern California. Harriet learned about the Peptoc poster project while doing research for a social-emotional learning and writing class she was designing for elementary school teachers. She reached out to us, and we gladly accepted her invitation to spend an afternoon making posters with over twenty of the current Rotary foreign exchange students.

PEPTOC: What do you think is so impactful about the exchange program?

BRIAN: The Rotary Club has several peacebuilding and fellowship programs around the world, but I think youth exchange is one of the programs that really does build peace because if you know people from another country, and you have friends in other countries, and you've been there, and you know the culture—it's harder to hate that country.

HARRIET: I like how they try to have the students stay with three different families just to break down those stereotypes so they know that not everybody in a country lives the same way. They also need to know about their own country, warts and all, so they can say, "These are things I appreciate, and these are the problems we are having right now."

BRIAN: One of the things we found is that the kids who come back are very different from the kids who left. They're more mature, they're more self-assured, they're more ready to take on the world.

PEPTOC: Why do you think the poster project was such a success with the students?

HARRIET: Because they're on a big adventure, everything is new, and they need support. I think it really helped them to be empathetic and to say, "If I feel scared, or I feel down or sad or worried, what do I want to hear? I could benefit from putting that out there, and I could probably expect that someone would reflect that back."

PEPTOC: What encouraging advice do you share regularly with each other and with the exchange students?

HARRIET: I like to acknowledge that life is hard and beautiful. It's not only one or the other. I made a poster with my students and it said, "It's okay to be blue; it's one of the colors in the rainbow."

BRIAN: What I learned from my wife was, "I don't want you to solve my problem; I just want you to listen to my problem." And a lot of times, that's exactly what the students need. They just need someone there, who they trust, who will listen to them. That's the case for most people—they just want to be heard.

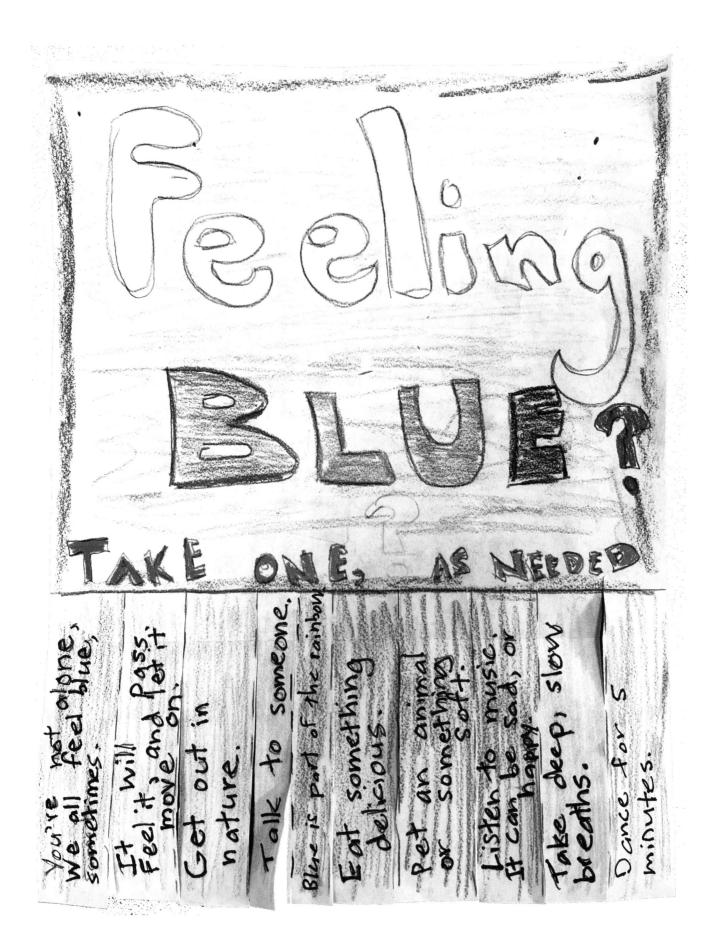

Feeling
BLUE?

TAKE ONE, AS NEEDED

You're not alone, we all feel blue, sometimes.

It will feel it, and Pass. move on.

Get out in nature.

Talk to someone.

Blue is Part of the rainbow.

Eat something delicious.

Pet an animal or something soft.

Listen to music. It can be sad, or happy.

Take deep, slow breaths.

Dance for 5 minutes.

UKRAINE

Kristina is seventeen years old and grew up in Ukraine, in a small town near the Carpathian Mountains, close to the Hungarian and Romanian borders. Her mom's family is from Hungary, and she grew up speaking Hungarian at home. When she started school, she learned Ukrainian and picked up Russian through TV, radio, and games.

We met Kristina through our work with the Rotary exchange program, though she wasn't technically an exchange student. Ten months prior to our meeting, a friend of Kristina's family had called to offer their home in California so that she could escape the 2022 Russian invasion of Ukraine. When her mom asked if she wanted to go, she answered, "To the other continent with the language that I'm not speaking that well? Yeah, let's do that." She went through the arduous task of getting the right paperwork, took two long bus rides across borders, and finally flew to California.

It was an honor to speak with Kristina, who expressed herself eloquently in her fourth language.

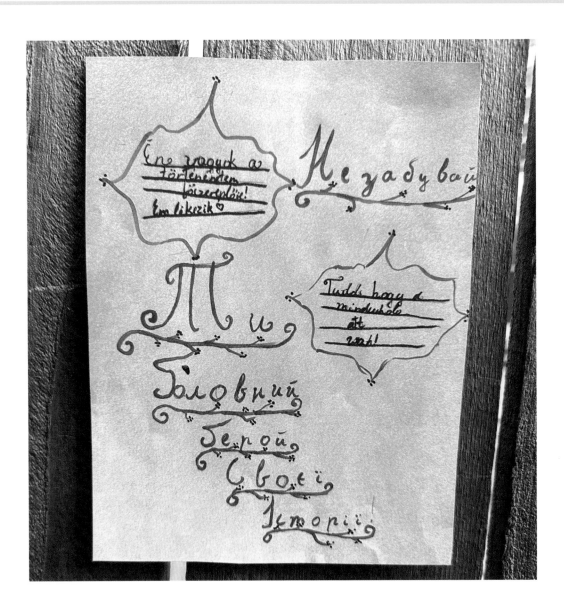

PEPTOC: Can you tell us about your Peptoc poster and what the message means to you?

KRISTINA: I think that a lot of times, we think about and care about others more than we care about ourselves. I thought to put "you are the main character in your own story" because you're living your only life. Or maybe we only know about one life, or maybe we only remember one life—and I don't think that we should use it for pain. Just don't forget that the main thing you have is you. Don't forget who you are.

PEPTOC: Why did you choose to write in both Hungarian and Ukrainian?

KRISTINA: Ukrainian is the language that I've spoken the most in my life and Hungarian is like a love language for my family. I think those two languages are important for me to see together. Because in this war situation, Hungary is not supportive of Ukraine at all, which is sad. So I thought this kind of language connection would also bring our countries closer.

PEPTOC: Based on your experience, do you have any advice for other young people who would like to make a positive impact in a challenging time for the world?

KRISTINA: I think the main advice is the simplest—don't give up when you think you should. Don't give up your ideas and your life. Just don't do it. Go for the dream you were working so hard on. If you have great ideas or any small ideas that no one has done before, just keep going, doing what you do the best. And I think if you do it well, you will have an impact on your community, but there will also be an impact on this world.

PEPTOC: What are your hopes and dreams for the future?

KRISTINA: So much war has happened during all of human history because we couldn't learn this hard and really important lesson. I wish we would teach not only about history but about how not to repeat the same mistakes again and again. People don't know how to control and manage their power. They think that they are the most important human being, and they don't care about others. And this is the problem. I think we should teach people about morality and how to live in society because we are human, and we need other people. We need to learn how to be respectful and how to be humans to each other.

WE NEED TO LEARN HOW TO BE RESPECTFUL AND HOW TO BE HUMANS TO EACH OTHER.

PEPTOC: What's it like being connected to other young people who aren't from your country?

KRISTINA: They are sharing their own experiences, their own lifestyle, and it's so cool to learn from those people because maybe something that you think is normal, it's not normal for others, or just different for others; something that you think is usual for you, it's not for them. It's a really good way to learn.

INDIA

Thamarai is a multifaceted project that serves two villages in Southern India: Edayanchavadi and Annai Nagar. It provides holistic wellness programs and youth education focused on arts and ecology. Savithri is a former student at Thamarai and a lead facilitator in the program. Since earning her degree in civil engineering, she has returned to the school to help guide the next generation.

PEPTOC: Why do you think a creative project like Peptoc resonated with your students?

SAVITHRI: [Creativity] creates possibility among young people. It removes shyness; it removes fear. Most of the Thamarai students love drawing. It's an easy way to express their feelings, whether that's happiness, sadness, or enjoyment. It is a wonderful opportunity to build confidence.

PEPTOC: What do you love about working with young people?

SAVITHRI: Working with young people is much more comfortable for me in the sense that there is no judgment. When I'm at Thamarai, I feel joyful and forget all my personal difficulties.

PEPTOC: How do you see your students' relationship to creativity change over childhood and adolescence?

SAVITHRI: If I ask children in first grade up to fifth grade to write a story, they prefer to express that story in drawing rather than writing. They always ask me, "Can I draw instead of writing a story?" If I ask the older kids between fifth and ninth grade to write a story, they are very happy to act out a drama or to express that story through dance. This is what I can offer the children: I allow them to express however they're comfortable—whether that's drawing, painting, dancing, or drama.

PEPTOC: What do you think adults have to learn from kids?

SAVITHRI: Children sometimes ask funny questions, but they make us think deeply. We may think, "They are very small; they don't know very much," but if we let them, children's questions can challenge us.

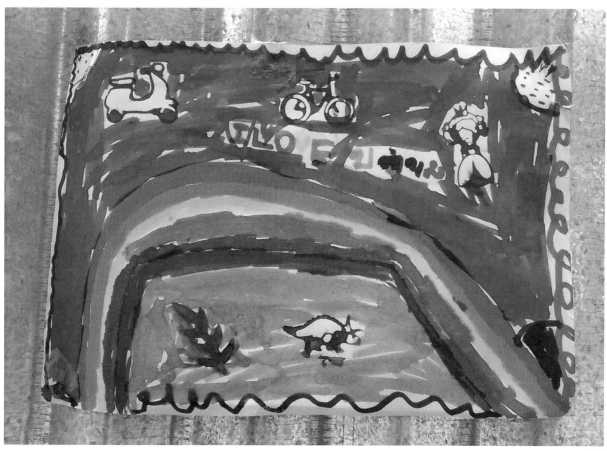

(Translated from Tamil)
I love rainbows.

NEW YORK, USA

Kelli Maass, an English teacher at Bronx River High School, New York, introduced the Peptoc poster project to her students as part of a nonfiction writing class. The students hung up their completed posters around the school, and for extra credit, they were encouraged to post messages in their communities, too. Some students even made copies of their posters and put them on car windshields. Maass was inspired by her students' enthusiasm for the project and has been sharing her story to encourage other teachers around the world to participate.

PEPTOC: As a high school teacher, what have you observed your students grappling with recently—both personally and in the world?

KELLI: I've been a teacher for a really long time—this is my twenty-fourth year. It has been a real struggle for me this year to get students to care about anything. Before the COVID pandemic, they thought they could make a difference in the world, and they had the desire to do so. Since COVID, the apathy has been so strong—but this project changed that.

PEPTOC: Why do you think your students were so interested in participating in the poster project?

KELLI: I told my students, "I know you probably aren't going to go up to a stranger and say 'you're beautiful,' but you can put it up on a sign, and maybe someone will walk by who really needed to hear that. You don't know what anyone is dealing with in life, and you don't know how lonely someone may feel. You might be the one person who helps them.

YOU DON'T KNOW WHAT ANYONE IS DEALING WITH IN LIFE, AND YOU DON'T KNOW HOW LONELY SOMEONE MAY FEEL. YOU MIGHT BE THE ONE PERSON WHO HELPS THEM.

Lots of times, with art projects, kids just take a sheet of loose leaf and write a quick message on it, and they're done. But with this project, they really took their time. They took pride in it.

I think they understood the power behind the notion that you are giving something you might also want. They saw that they could do something small and have that ripple effect. A kind word can go a long way.

PEPTOC: How did their fellow students react when they put up the posters around the school?

KELLI: I think about all the signs that get put up and then ripped down at school—but the posters the kids made are still up, even in the areas where teachers don't normally go. I think that says a lot. It's nice to see that this is what these kids really care about.

I love how so many people came up to me from all walks of life, saying how much they loved seeing the messages. That is just a testament to how important this is. Everyone needs those reminders that it's going to get better and that you're not alone.

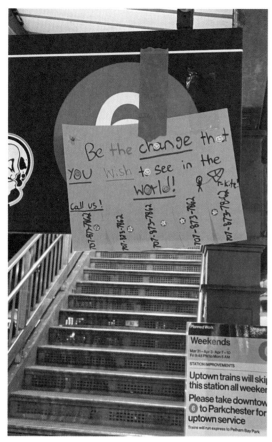

Cesar, age 16, Bronx, New York

"Many have to go to work and school using the train. I know the struggle of waking up every morning just to get on a busy train, so I wanted to spread kindness here for people who have a long day ahead of them, so they can start it off with a smile on their face."

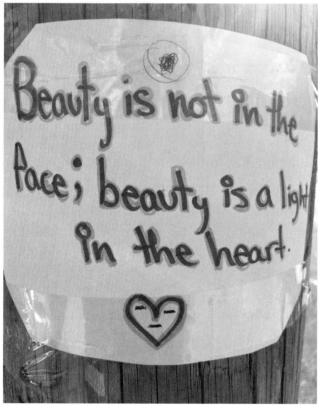

Oscar, age 16, Bronx, New York

SOUTH AFRICA

Ruth and Cecil Hershler grew up in apartheid South Africa. When they were in college, they learned about the corrupt and segregated school system and the horrible conditions in Black schools—a stark contrast to the economic and social privilege they experienced as white people. They decided to dedicate their lives to building the trust and relationships needed to support victims of racist government and policy, starting with improving the conditions of underfunded Black schools.

Years later, they founded Education without Borders. The organization provides dynamic educational programs for disadvantaged and at-risk children based in South Africa and Canada.

PEPTOC: What does creativity mean to you?

RUTH: I think creativity allows one to unblock all those things that are inhibiting one from expressing oneself. Creativity is an opportunity to allow one's mind to flow freely.

CECIL: It's about getting rid of borders in our minds. We are inundated with restrictions and regulations, and even how to write, how to paint, how to draw. There's so much "how to." In a sense, that restricts you. It's good to listen but not necessarily good to endlessly follow instructions. You are somehow born, and for a few years, you are in touch with the pure form of your voice because you're not yet restricted by people telling you what to do or how to do it—or even worse: "Don't do it." There's all this fear, and it mutes you a little bit, doesn't it? We were all children; we can all remember that we had a period when our voices were freer. We have to struggle now to be childlike.

> YOU ARE SOMEHOW BORN, AND FOR A FEW YEARS, YOU ARE IN TOUCH WITH THE PURE FORM OF YOUR VOICE BECAUSE YOU'RE NOT YET RESTRICTED BY PEOPLE TELLING YOU WHAT TO DO OR HOW TO DO IT—OR EVEN WORSE: "DON'T DO IT."

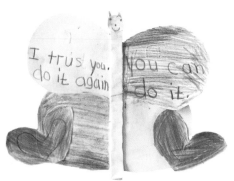

RUTH: I'm struggling with the idea of how to keep that creative part alive in you when, at the same time, you have the social pressures telling you to do this and not do that. You may have a teacher who stifles you, and you may stop; you may never do anything else creative again. From my personal point of view, I know that's affected me a lot.

CECIL: Yes, for example, a lot of people don't sing because somehow, at some point in their growth, they were told, "You don't know how to sing."

PEPTOC: How does the Peptoc poster project foster creativity as you define it?

CECIL: In its own way, it is trying to allow young people to use their voices without restriction. You've given them a broad theme, but you're not telling them what to write, and you're not telling them how to present it. You're open to whatever they give you. That is one way of keeping the creative voice alive.

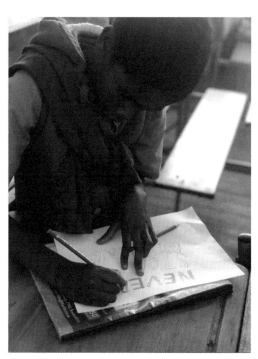

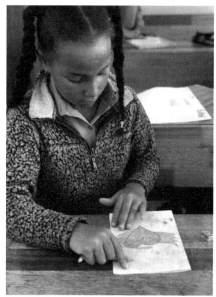

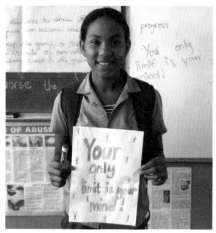

COSTA RICA

Zoe Holtermann is a nineteen-year-old student from San José, Costa Rica, who brought the Peptoc poster project to a local program for at-risk girls ages five to twelve. She was deeply moved by her experience working with such a wise, powerful group of young girls.

PEPTOC: What was it like to bring Peptoc to this group?

ZOE: It was an incredible experience. These girls have gone through some unimaginable things, so seeing their eagerness every time they thought of a quote and their dedication while writing and drawing their messages was more than inspiring.

I brought them colored papers and markers, and they were excited right away—each of them yelling for their desired color. I told the girls to write something that they would say to a person who was sad or having a hard time. Some of them knew what to write right away, telling me that their messages are what they say to themselves when they are not feeling their best. Others had a bit of a harder time deciding what to write, yet all of them made three or more posters.

Despite the tragic situations many of these girls have lived through, they are here, always with a smile on their faces. You never hear them complaining or worrying. If adults learned to let go sometimes and think like kids, I believe it would bring them peace.

PEPTOC: What do you do that helps you when you are having a hard time?

ZOE: When I'm having a hard time, I like to remind myself that I have gotten through other difficult situations and will get through this one. Happiness isn't constant. Hard times are inevitable for humans. Everyone has their own problems, no matter how much it looks like they don't. I try not to compare because everyone's problems are different, but that is also comforting in a way because you are never alone. Everyone has something of their own to deal with.

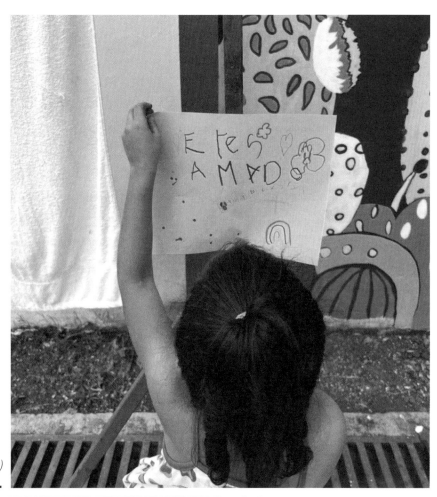

(Translated from Spanish)
You are loved.

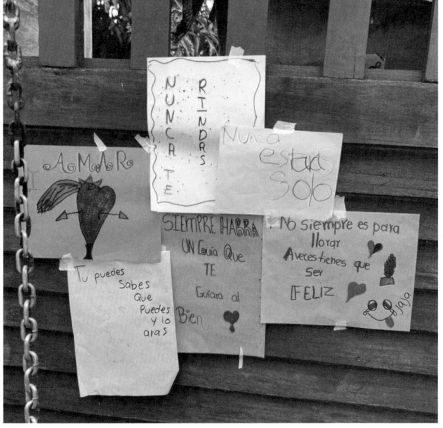

Clockwise from center:

Never give up

You are never alone

It's not always something to cry about—sometimes you need to be happy.

There will always be someone to guide you to the good

You can, you know you can, and you will do it!

LOVE

JOIN THE MOVEMENT

We invite YOU to make your own Peptoc poster!

Read through our suggestions to get started, but feel free to interpret and expand upon this project however you like. Perhaps, instead of a poster, it's a community performance or a series of live pep talks between strangers in a park!

The possibilities are limitless. There are no rules.

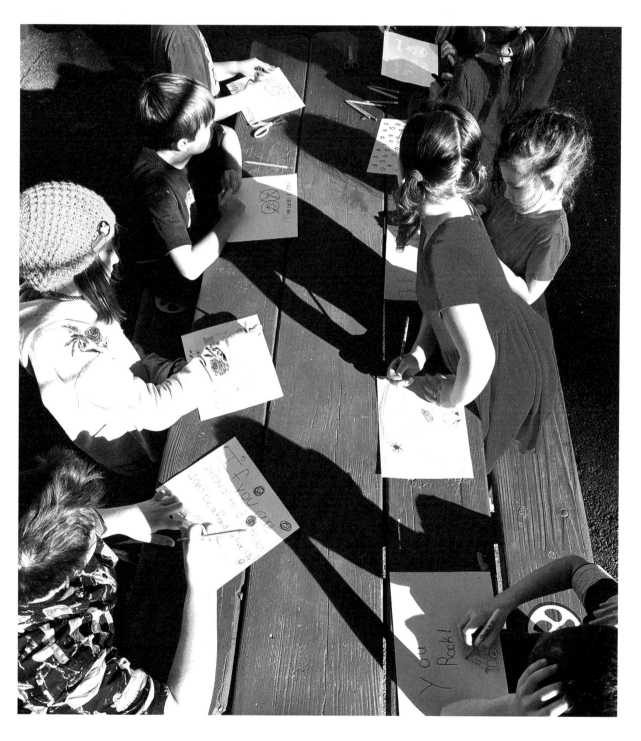

THE GUIDE

First, a pep talk:

It takes bravery to express yourself and share your thoughts with people you don't know! This is the poetry of public art: You put your work out into the world, letting go of any control over how others interact with it. This can be scary, so take care and take your time. Above all, keep it fun!

1. Think About It

What could you do or say to help someone who is having a hard day? Think about a time when you were feeling sad, angry, or frustrated. What helped you? Talk to others about what has helped them through challenging times.

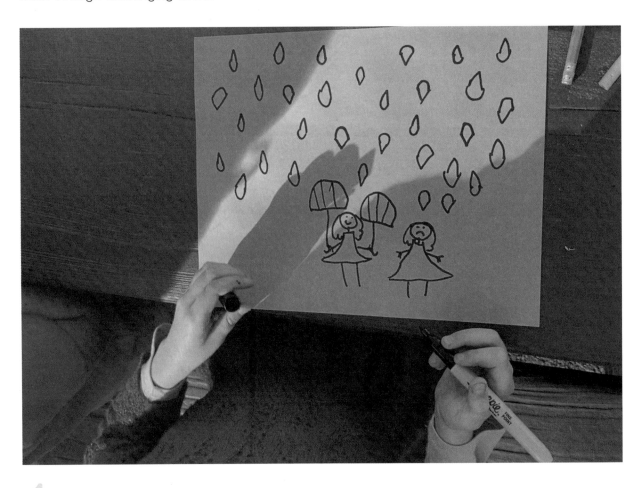

2. Make Your Poster

Draw your idea on a piece of paper. Use a dark marker or bold marks so your message stands out. Your poster can have images, words, or a combination of both. Keep your messages positive, and write in the language you're most comfortable speaking.

A note to adult facilitators: When supporting young people in this project, allow them the space to choose how they will express themselves. Misspellings are okay! Resist the urge to "fix" or edit.

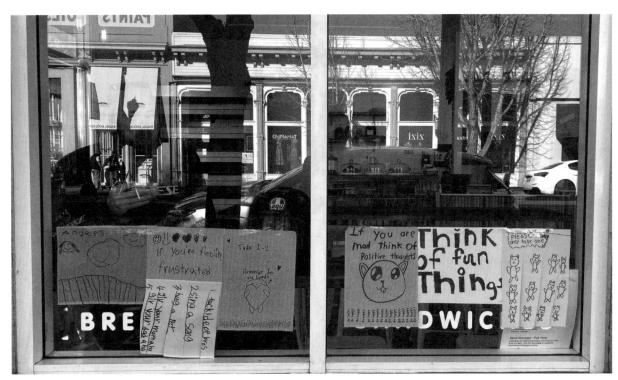

3. Hang Your Poster

Hang your poster in a public place where anyone can see it! Some ideas: a lamppost, a public bulletin board, walls at work or school, or local shop windows. Just make sure you ask permission before hanging your work on private property. (People love these posters, so don't be shy to ask!) If you can, make copies on colorful paper and distribute them widely!

Remember: It's okay to participate in a way that works for you. If you prefer to hang a poster up in your home, just for yourself, that counts! If you need to bring a friend with you to display your poster in your community, that's great too.

Thank you for sharing your creative spirit! If you feel inspired to do so, share your work even more widely using the hashtag #peptocposter and tagging @peptockids on Instagram.

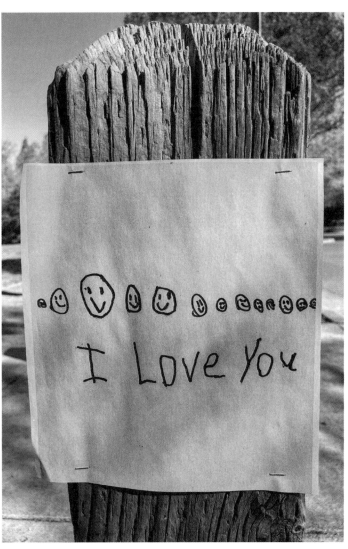

THANK YOU

This book would not exist without the love and participation of all the young people who took part in Peptoc—whether or not their work appears on these pages. This book is a tribute to them.

We want to thank the West Side Elementary School community for everything they've done, including completely embracing the wild ride of media visits, fundraising efforts, televised interviews, and more. Thank you to Principal Rima Meechan, who stood by in support every step of the way. Thank you to the students, teachers, staff, and families; the Felta Education Foundation Board; and the West Side School Board for your involvement. Thank you to Miriam, who supported the translation of our writing into Spanish, and Tina and Susanne, for fielding all the calls and emails. Thank you to the sixth-grade class of 2022–23 for their help in making extra posters and drawings. Thank you to Sydney Henderson for her Saturn drawing on the cover, and a special "hats off" to Elizabeth Miranda for sharing her fabulous words, which became our title!

Peptoc would not have been so successful without our sponsors, who helped us cover the hotline fees and all the people who helped spread the word about the project. Thank you to Twilio for hosting the hotline and for their partnership! Thank you to Kerry Benefield of the *Santa Rosa Press Democrat*, who wrote the very first news article on Peptoc, and to all the other amazing journalists who followed.

Jessica would like to thank her family for supporting her through this adventure: Sébastien, for keeping the household together as she navigated every aspect of Peptoc; Rosalie, for sharing her luminous eleven-year-old voice to welcome callers on the hotline, and for her wonderful poster designs; and August, for his Peptoc logo design, his participation in hanging the posters, and his voice recordings for the hotline menu options.

Asherah has her fiancé to thank: Ethan, for connecting her to so many amazing groups and individuals around the world and for cheering her on throughout this project; Whit Logue, for adventuring with her to hang up the original posters all over Healdsburg, and Sean Rune, for documenting the process; and her parents, who made it abundantly clear that creativity is a part of everyday life.

We would also like to thank the educators, family members, and others who encouraged young people around the world to participate in this project. Thank you to Ali Rufrano-Ruffner, Erica Mandell, and Peri Law in Philadelphia, as well as Lauren Frost from Santa Rosa, California, who were some of the first people to enthusiastically respond to the call for Peptoc posters. Thanks to Brian and Harriet from Rotary, as well as Nancy Dean, for your support and connection to the wonderful exchange students. Thank you to Luluwa Lokhandwala and Beenish Sarfaraz from Pakistan; Kelli Maass, teacher from the Bronx; and Savithri Chandrakasan, Bridget, Gunavathi, Ananthi, and the other facilitators of Thamarai. Thanks to Laen, who connected us to his parents Ruth and Cecil Hershler, founders of Education without Borders, and Mickayla Smith, who facilitated the project in South Africa. Thanks to Lauren Hartman, art teacher at Healdsburg Junior High; Clare Joyce, educator from Ireland; Jordan Palmer and King Boateng from Akwaaba Volunteers in Ghana; Allie Hartley, educator from Windsor; Isabelle Hebraud and the staff at Ecole Internationale Antonia in Montpellier, France; Zoe Holtermann and family in Costa Rica;

Gianna Davy and Gabe; Sarah Walsh; Naomi Weiss-Laxer and Dany Torres; Jali Bakary and their family; Steve Pile; Anik Meijer-Werner; Elmont Memorial Library; Ginny Duncan; Brook McGinnis; Sophie Skipper and the Teen Council at Wiregrass Museum of Art in Alabama; and so many more.

Thanks to those who supported us in many other ways: Keiko Sato-Perry, who translated our poster guide into Japanese; Robert Hildreth, who helped us articulate our vision; Linus Lancaster for his encouragement and mentorship; Kelly Ebeling for showcasing our project in her show; Christina Amini for her guidance and support; and the Creative Sonoma staff who work to elevate local arts and culture.

Our deep gratitude to our editor, Melissa Rhodes Zahorsky, the team at Andrews McMeel, and to our literary agent, Kate Woodrow of Present Perfect Lit.

We also want to thank the visionary creatives in our lives—our teachers—especially Susan O'Malley, whose pep talks with collaborator Christina Amini and her posters from her series "Advice from My 80-Year-Old-Self" have had a tremendous influence on our work as artists and educators.

Finally, we'd like to celebrate our good fortune in finding one another as creative partners. We feel so lucky to have met one another, and we often marvel at our synergy thanks to our shared humor, complementary skill sets, and mutual commitment to expanding definitions of creativity as a means to contribute to a better world.

For more information on Peptoc, go to Peptoc.net.

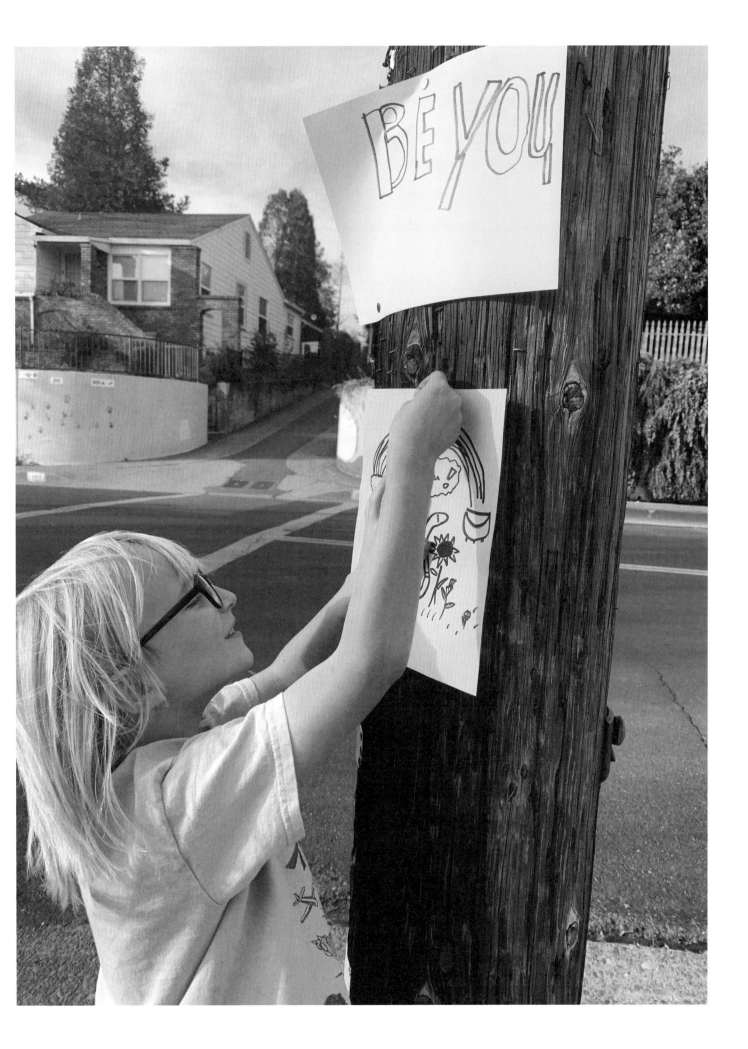

ABOUT THE AUTHORS

Photo by Bryan Meltz

ASHERAH WEISS is a community artist and interdisciplinary educator based in Northern California. She holds her California teaching credential for art and taught full-time through the early COVID pandemic at a public middle school. Before and since she has worked as a creativity mentor and facilitator with folks of diverse ages and abilities. Her work focuses on discovery and play and continues to expand all the time. Most recently, she has been exploring improvisational theater as a student and teacher.

Asherah has been the cocreator of many emergent spaces for creativity. She founded and ran womb space collaborative arts, a living room for creative community engagement. She also cocreated Open Envelope, which set up public spaces for people to handcraft notes of love and send them in the mail, including "Love Letters to Santa Rosa," a response to the first catastrophic fire in Sonoma County.

Asherah is currently the programs director at Artstart, an educational arts nonprofit that mentors youth while creating beautiful murals, mosaics, and more in the community.

To connect, go to www.AsherahWeiss.com.

Instagram: @asherah.weiss

JESSICA MARTIN is a multi-disciplinary artist, educator, and curator based in Northern California. Her artwork, community public art projects, and education programs focus on our relationship to creativity and joy.

Jessica studied Anthropology at Vassar College and did her fieldwork in Madagascar and France. She received her MA at California College of the Arts. Jessica has been an Artist in Residence for Google, and her work has been shown throughout the Bay Area and abroad, including at the Headlands Center for the Arts, Southern Exposure, ProArts, Amelie Maison Paris, Institute of Contemporary Art San Jose, TedX, and at national film festivals. Her work has been awarded grants from Creative Sonoma and the California Arts Council.

In addition to her work as an artist, Jessica is the founder of Roving Venue (RV), an itinerant gallery that produces innovative temporary public art projects in rural Sonoma County, California. She is also the arts program director and lead teaching artist at West Side Elementary, where she and Asherah Weiss launched the Peptoc project.

For more information about Jessica's work, go to www.JessicaMartinArt.com.

Instagram: @Jessicamartinart

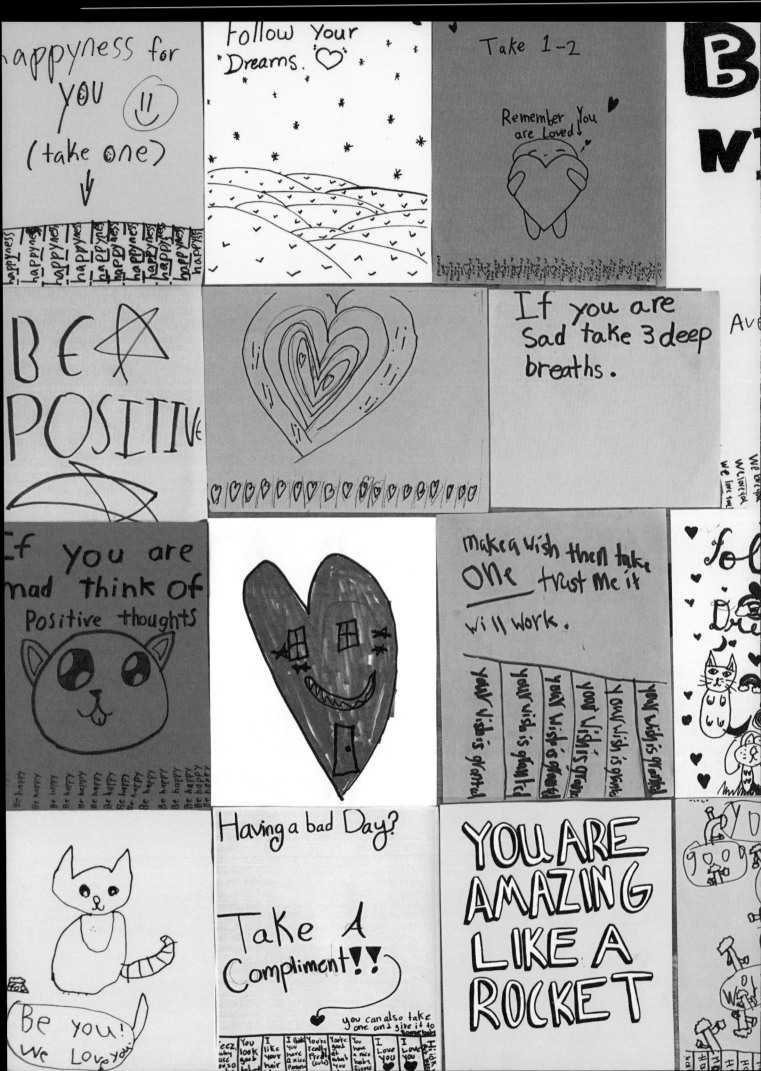